COLOR EXERCISES
FOR THE PAINTER

COLOR EXERCISES
FOR THE PAINTER

BY LUCIA A. SALEMME

Foreword by Alexander Calder

WATSON-GUPTILL PUBLICATIONS, NEW YORK

For my dear nephew
Private First Class Joseph Autorino, Jr.
(1946-1969)

Paperback Edition
First Printing, 1979
2 3 4 5 6 7 8 9/86 85 84 83 82

First published 1970 in the United States by Watson-Guptill Publications,
a division of Billboard Publications, Inc.,
1515 Broadway, New York, N.Y. 10036

Library of Congress Catalog Card Number: 77-98989
ISBN 0-8230-0725-1
ISBN 0-8230-0726-X pbk.

Manufactured in Japan.

FOREWORD

A few years ago I told Lucia Salemme that she would have to choose between realism and fantasy in her painting. She feels she has gone toward fantasy, but I think that her ideas may be fantastic, that her elements, i.e. the parts of her scenery, are very realistic, made of iron and concrete and very solid materials.

Her colors are between primary and secondary, with pale blues and winey reds, and a sort of transparency over most of the picture. (I think I tried to encourage her to use red, which is my favorite color.) All her paintings are imbued with mystic breezes and gusts of air. I'll admit that is rather eerie.

But eerie or not, that is really not the question. I feel that she has stature as a professional painter. And I am sure that in this book she establishes herself also as a fine and dedicated teacher.

Alexander Calder

ACKNOWLEDGMENTS

I would like to thank Alexander and Louisa Calder for their steady encouragement and moral support, Donald Holden who convinced me I was capable of writing this book, and Susan Meyer who patiently acted as mentor and editor. I am also grateful to Victor D'Amico of the Museum of Modern Art's Peoples Art Center and Dean Warren Bower of New York University who launched me on my teaching career, William Zierler, in whose gallery my paintings are to be exhibited, Elizabeth Ferraro Rodgers, who was responsible for typing my many notes, and Dorothy Meyer, a very special art student.

I should also especially like to thank the Whitney Museum of American Art and the Solomon R. Guggenheim Museum, Eleanor Saidenberg of the Saidenberg Gallery, Terry Dintenfass, Acquavella Galleries, Inc., and Harold Reed Gallery, who generously contributed the excellent transparencies reproduced in this book. To my sons, Vincent and Lawrence, and to the numerous students who carried out many of the exercises put forth in this book I extend my deepest gratitude.

CONTENTS

Foreword, 5

Introduction, 11

1. Let's Get Started, 13

A list of painter's terms, 13 • The materials you'll need, 17
What paints should you use? 17 • Mediums, 18 • Cobalt drier, 19 • Canvas, 19
Brushes, 20 • Palette knives, 20 • Additional tools, 20 • Tools for collage, 20
Exercises to get started, 21 • Exercise 1: exploring the primaries, 21
Exercise 2: exploring the mass tones, undertones, and half-tones, 22
Exercise 3: variations within the color families, 23 • Exercise 4: using the earth colors, 24
Exercise 5: achieving a plastic quality, 25

2. Color Temperature, 27

What is color temperature? 27 • Exercise 6: "getting to know you" exercise, 28
Exercise 7: meet the hot colors, 30 • Exercise 8: painting a hot picture, 31
Exercise 9: color matching test, 32 • Exercise 10: direct painting exercise, 32
Exercise 11: getting to know the cold and cool colors, 32
Exercise 12: painting a cool picture, 34 • Exercise 13: and the warm colors, 35
Exercise 14: for a very cold mood, 36 • Exercise 15: combining warm and cool, 37
Some concluding remarks, 38

3. The Complementaries, 39

Exercise 16: laying out the complements, 39 • Exercise 17: when do they vibrate? 41
Exercise 18: plastic quality in a landscape, 42
Exercise 19: when do complements cancel each other? 43
Exercise 20: how do complements react when juxtaposed? 44 • One family at a time, 45

Exercise 21: calming the cool blues with orange, 45
Exercise 22: all the reds with green, 46 • Exercise 23: all the yellows with violet, 47
Exercise 24: all the grays with red, yellow, and black, 48
Exercise 25: riot of colors day! 49

4. Color Values, 51

Exercise 26: value mixing practice, 51 • Exercise 27: a collage of values, 52
Exercise 28: cityscape in values of gray, 53 • Exercise 29: graded scale painting, 54
Exercise 30: juxtaposing light and dark (chiaroscuro), 55
Exercise 31: portrait from life in chiaroscuro, 56 • Exercise 32: exciting shadow areas, 57
Exercise 33: A still life in half-tones, 57 • Vibrating the half-tones, 58
Exercise 34: vibrate the half-tones with complementary colors, 59
Exercise 35: the half-tone reflecting its adjacent color, 61
Exercise 36: with the complements and adjacent colors together, 61
Exercise 37: different gradations in individual colors, 62
Exercise 38: explore the mass tone, 64 • Exercise 39: color values in a collage, 65
Exercise 40: color values in a landscape, 65

5. Color Perspective, 67

Local color and atmosphere, 67 • Exercise 41: Landscape in a rainy atmosphere, 68
Creating depth with color, 69 • Exercise 42: which colors recede, which advance? 69
Exercise 43: a still life in depth, 70 • Exercise 44: creating depth in a landscape, 71
Exercise 45: a collage in depth, 72

6. Composing with Color, 74

Exercise 46: relationship between areas of same color but different size, 75
Exercise 47: colors of different families, 76 • Exercise 48: adjacent colors, 76
Exercise 49: color affects shape, 77 • Exercise 50: lights and darks affect shape, 78
Exercise 51: color shapes in a still life, 78 • Exercise 52: poetic effects with color, 79
Positive and negative space, 80 • Exercise 53: portrait: toning down the positive space, 80
Exercise 54: cheering up the negative space, 81
Exercise 55: combining negative and positive spaces, 82
Exercise 56: juxtaposing linear and amorphic shapes, 83 • Weight and visual balance, 84
Exercise 57: balancing the same size and color, 84
Exercise 58: balancing brilliant colors, 85 • Different harmonies, 87
Exercise 59: harmonizing colors, 87 • Exercise 60: antagonizing colors, 88
Exercise 61: discords in shapes of equal size, 89
Exercise 62: discords in various shapes, 90 • Exercise 63: abstract dynamic contrasts, 90
Exercise 64: dynamic contrasts in a landscape, 91 • Movement and rhythm, 92

Exercise 65: free form movement, 92

Exercise 66: linear and amorphic shapes affect movement, 93

Exercise 67: movement with overlapping planes in similar value, 94

7. Painting Techniques and Color, 95

How glazing affects color, 95 • Exercise 68: glazing dark over light, 129

Exercise 69: portrait study of a brunette, 130 • How scumbling affects color, 132

Exercise 70: scumbling an old painting, 132

Exercise 71: scumbling a country landscape, 133 • Let your eye do the mixing, 134

Exercise 72: optical mixing, 134 • Juxtaposing strokes, 135

Exercise 73: juxtaposing strokes in a still life, 136 • Textural effects and color, 137

Exercise 74: still life of organic things: impasto, 138

Exercise 75: a textural landscape: impasto and scumbling, 139

Exercise 76: a street scene in texture: combined techniques, 140

Exercise 77: a draped figure study: combined techniques, 141

Exercise 78: textural effects with collage, 142 • Creating light effects, 143

Exercise 79: painting a luminous effect, 143 • Exercise 80: painting a lustrous effect, 144

Exercise 81: filmy effects with scumbling, 145

8. The Feeling of Color, 147

Expressing moods with varied techniques, 147 • Exercise 82: happy and gay mood, 148

Exercise 83: sad and somber still life, 148

Exercise 84: frightening and foreboding scene, 149 • Exercise 85: celebration, 150

Rhythm and moods, 151 • Exercise 86: painting a calm mood, 151

Exercise 87: expressing serenity, 152 • Exercise 88: expressing excitement, 153

Exercise 89: expressing a buoyant mood, 153 • Exercise 90: expressing stability, 154

Exercise 91: expressing an introverted mood, 155

Exercise 92: expressing a graceful mood, 155 • The final step, 156

Index, 158

LIST OF COLOR PLATES

Vincent Van Gogh: *The Man is at Sea,* 97
Raoul Dufy: *Les Courses á Deauville,* 98
Pablo Picasso: *Rembrandt and Saskia,* 99
Georges Braque: *Le Gueridon,* 100
Attilio Salemme: *Tragedy,* 101
Lucia A. Salemme: *Coney Island,* 102
Robert Gwathmey: *Wild Roses,* 103
Attilio Salemme: *The Sacrifice,* 104
Alexej von Jawlensky: *Helene with Red Turban,* 105
Stefano Cusumano: *Violin Maker's Bench,* 106
Georges Seurat: *Horses,* 107
Byron Browne: *Clown,* 108
Lucia A. Salemme: *Night in the Clairvoyant City,* 109
Attilio Salemme: *Self-Portrait 1940,* 110
Attilio Salemme, *Ipso-Facto and a Little X,* 111
Milton Avery: *Conversation,* 112
Paul Klee: *Runner at the Goal,* 113
Vasily Kandinsky: *White Form in a Landscape,* 114
Kees Van Dongen: *Paysage de Hollande,* 115
Attilio Salemme: *Still Life with Wine Bottles,* 116
Gino Severini: *Courses á Merano,* 117
Juan Gris: *Nature Morte aux Fruits,* 118
Alexander Calder: *Shaded White Planets,* 119
Lucia A. Salemme: *Early Morning,* 120
Pierre Bonnard: *Dining Room on the Garden,* 121
Nicolas De Staël: *Composition Fond Rouge,* 122
Lucia A. Salemme: *Nostalgic World of Broken Buildings,* 123
Lucia A. Salemme: *House in the Sun,* 124
Franz Marc: *Primal Beasts,* 125
Karel Appel: *Untitled,* 126
Marie Laurencin: *Jeune Fille Avec Anemones,* 127
Vasily Kandinsky: *Above and Left,* 128

INTRODUCTION

In painting, good craftsmanship and high standards go hand in hand. As children, you did many things naturally and without much effort. You sang and shouted, you ran, you jumped, and reacted quickly with spontaneity, getting at once to the essence of things. Beginning to paint resembles this youthful exuberance: your use of color seems natural. However, spontaneity seems to diminish with time. You must now rely more and more on the skillful handling of materials and techniques if you expect to express your ideas in a lasting and successful manner. Eventually, you'll discover that the acquired—not inborn—skills are now the chief means by which you recapture some of the spirit of what once came naturally. You can readily see how important it is that you learn the different skills of your craft.

We all know that there are few geniuses born, but it's heartening to note that even the genius goes to school! Therefore, a systematic development of these skills must come first. Here's a plan for developing your career as an artist.

First, learn and study thoroughly the skills of your craft: learn to draw, learn different techniques of painting, understand your materials, and all about color and paints, both in theory and in practice.

Secondly, you should develop a superior, high level taste for art. This is best accomplished by studying the history of art with art books and trips to museums. First hand exposure to works by the Masters, both old and modern, is one thing you'll have to do on your own, and is a good way to get you away from the solitude of your studio and out into the world of art.

Thirdly, develop a way of painting your ideas in a style of your own. This can happen only with time and practice and only after you've discovered a theme that closely expresses your innermost feelings. You'll find that your subject material becomes doubly significant when you have a personal way of painting it. When your skills have become reflex actions, when you're no longer concerned objectively with craft, a unique and personal style of expressing yourself is inevitable.

Last, but not least, it's reassuring to know that when you'd like to repeat one of your successes, when the "how did I ever do that" moment arrives, you'll know exactly how it *did* happen, because your critical ability and good judgment are now an integral part of your makeup.

Although it's true that the writer writes, and the dancer dances, and the painter paints, your conscious know-how is inevitably a necessary part of your skill if you ever expect to produce work of lasting significance.

Thus, this book is geared expressly for you, the student of painting. You can refer to it, use it to refresh your beginnings, and specifically to learn what color is all about.

1 LET'S GET STARTED

If you know your history, you'll remember that all the Greek philosophers were interested in the phenomenon of color. Pythagoras called color "the surface of things." Plato saw color as a flame emanating from objects. Aristotle thought color was what made objects transparent. Leonardo said it was one of the two principles of art, one being color, the other form.

When Newton discovered that white light could be decomposed by a prism into a continuous band of varied colors, he was followed by the painters, whose conclusions were based primarily on what was *visible*. By actually making color with paint (pigments), they discovered that out of the basic colors—red, yellow, and blue—they were able to develop and produce all the other colors in the rainbow. Since we are also painters, all the exercises in this book will be based on the conclusions arrived at by the painters.

So let's get started, first by studying the following list of painter's terms and their meanings and then by diligently pursuing the exercises. In this chapter, the exercises are designed simply to get you started, a means of seeing the general characteristics of color. In later chapters, we'll go on to study these characteristics more closely, in greater detail, with more complex exercises. Here, however, we'll simply see what color is all about.

First, let's study the terms painters use, so that we have a working vocabulary for the book.

A list of painter's terms

Analogous Colors Colors that are adjoining or adjacent to the primaries, on the color wheel; colors related by having the same family

source or base. Cadmium yellow, yellow ochre, yellow-green, raw sienna, raw umber, and Van Dyke brown are all analogous colors.

Atmosphere The general mood of a painting and the visible effect of air, weather, and light on your subject.

Brilliance The degrees of brightness found in colors. This ranges from the maximum brilliance found in white paint to the zero brilliance found in black.

Casein Paint made from dried milk curd becomes a strong adhesive and has been used as a binder since earliest times. Although it is water soluble, casein has the consistency of oils.

Chroma The degree of brilliance or how much light the color releases.

Color Perspective The effect achieved by allowing color to create the illusion of depth.

Complementaries Colors lying directly opposite each other on the color wheel: e.g., red and green, yellow and violet, blue and orange.

Composition How the artist puts a picture together so that the colored and drawn shapes relate to and balance each other.

Cool Colors Most blues, grays, and greens are cool because they suggest cool places, such as water, ice, and sky.

Design The style or pattern you use to construct your composition. The manner in which you put together your picture.

Earth Colors The earliest known color to man, prepared from various ores and oxides found in the earth. They are permanent and low-priced because they are found in most countries. Earth colors are also the toned-down variations of the more intense primaries. For example, yellow ochre is a subdued yellow; Venetian red is a subdued cadmium red; green earth is a subdued viridian green.

Form The shape you give to the outside edge of a visual concept; such as the shape of a vase, figure, fruit, cloud, or tree.

Glaze Any transparent coat of paint layer superimposed over a dry coat of paint, so that the undercolor filters through.

Gouache (pronounced gwash) Opaque watercolor or a painting done in this medium. Paint is made from a mixture of pigments, water, and gum arabic.

Grayed-down The neutral, muted variation of a pure color. You create this by mixing in a little black, raw umber, or its complement to the color you wish to gray down.

Half-Tone The middle value of a color achieved by mixing color with its complement or a little black; for example, red mixed with a little green or black; yellow with a little violet or black; blue with a little orange or black.

Hue Another term for the word "color." The name of the color; e.g. red, orange, or green.

Impasto A thick application of paint, most easily achieved with oils or acrylics.

Intensity The strength of a color.

Line The outside edges of forms. Lines are also directional: up, down, sideways, and undulating.

Mass Tone The pure quality of your color as it comes from the tube.

Medium This word has two meanings. It is the substance with which pigments are mixed—water, oil, casein, wax, etc.—which, when added to pigments make them more fluid or more adhesive, and can hasten or retard their drying. The other meaning for medium is simply the material through which the artist expresses his ideas, such as clay, marble, oil, watercolor, etc.

Mineral Colors Paints prepared from mineral or metallic substances, such as cadmium and cobalt. They are permanent and are the most expensive group of artists' paints.

Monochrome A painting done in shades of one color. Opposite of polychrome.

Negative Space The area surrounding the main subject or idea in the composition.

Oil Colors or Oils Pigments mixed with linseed or poppyseed oil.

Opacity The opaque quality that does not allow anything underneath to show through in a painting. The opposite of transparency.

Organic Colors Pigments derived from animal or vegetable substances; usually not permanent.

Palette A tablet or any flat surface on which the artist mixes his paints. Also may refer to the typical set of colors an artist uses.

Pigment The coloring matter in powder form used in paints.

Plastic Anything that can be formed and modeled, such as man-made synthetic resins, clay, or plaster. The word also implies a three dimensional appearance.

Plasticity The tension created in a painting between one element and another in the composition when the lines, color, and forms mutually affect each other. To alter any one of these parts would disrupt the chain reaction of their movements.

Polychrome Anything painted in several colors. The opposite of monochrome.

Positive Space The solid area or form that is making the statement in the painting (e.g. the face in a portrait).

The Primaries Red, yellow, and blue.

Saturation The full strength or intensity of a color.

Scumbling Brushing dry color into a dry surface. Dragging the brush back and forth from subject to background, so that the ground color shows through.

Secondary Colors The three colors mixed from the primaries: orange (red and yellow); green (yellow and blue); violet (blue and red).

Shade A darker version of a color, which you can use to create the illusion of roundness and depth of a form.

Source of Light The place or spot in your composition from which the light is emanating.

Tint The lighter shade of a color (e.g. pink is a tint of red).

Three Dimensional The height, width, and depth of the forms in a composition.

Transparency The quality of allowing light to pass. Opposite of opacity. Certain oil colors are naturally transparent, such as rose madder, alizarin crimson, and green earth. All colors can be made transparent by adding a glazing medium.

Two Dimensional The height and width of the forms and spaces within the composition.

Underpainting A coat of gesso or an undercoat of quick-drying paint on the ground. By allowing the canvas to dry thoroughly, much of the

oil is removed and this dry, rough surface is good for when you want to do sharp contrasting color work. An undercoat of flake white (which has lead carbonate in the formula) is good for the glazing technique.

Undertone The color when mixed with white *(also, Top Tone)*.

Value The colors as they scale from their lightest—toward white—and their darkest—toward black.

Warm colors The colors that suggest heat, fire, or flames. Reds and yellows are the warmest hues.

Watercolor Transparent pigments, the same as aquarelles, made with a mixture of pigments and gum arabic.

Wet-on-Wet Blending and working one color into another while each is still wet. Paintings done in this technique seldom crack.

The materials you'll need

In this book, I've deliberately designed the exercises so that you'll need only a minimum of materials. The first step is to understand the names of the different materials so that you'll be able to select the colors suitable for the various exercises.

All the exercises call specifically for either oil paints or collage materials. Unlike the transparency of watercolors and inks, where the color is thinned with water and the paper is permitted to show through the colors (creating many accidental effects), oil paints offer the student the greatest amount of leeway for experimenting and mixing accurate variations in the exercises. Once this technique is mastered, it's a simple process to transfer what you've learned to any of the other opaque media—such as acrylics, gouache, casein, pastels. Acrylics can be used in exercises involving a great deal of impasto (thick applications of paint), because acrylics dry rapidly. Acrylics also do not chip or crack when used in large amounts. Gouache or temperas, water based opaque paints easily dissolved in water, can be used when you're in a hurry, because the paint dries quickly (in a matter of minutes) and are also very economical to use. Casein colors, on the other hand, are waterproof and more permanent once they dry. Collage exercises (used frequently in this book) are good for working with large flat color areas. Pastels can be used for the exercises involving pigments in their purest state.

What paints should you use?

For the exercises in this book, I recommend that you use student grade oil colors. Of all the student grade oil colors, both the Bellini studio size by Bocour Artists' Colors Inc. and the Pre-Tested permanent oil color for students by M. Grumbacher, Inc. will do. Both put out fine color charts which you should be sure to obtain. You can do so by writing to one of their branches in the city closest to your home. While the color charts are a quick guide to identifying the colors, however, they cannot compare to seeing the real color, because there are qualities the actual paints possess that can never be accurately printed.

Here are the colors you'll need for the book:

cadmium yellow	Venetian red
cadmium yellow medium	cadmium orange
cadmium yellow deep	yellow orange
lemon yellow	ultramarine blue
Naples yellow	cobalt blue
yellow ochre	Prussian blue
raw umber	cerulean blue
raw sienna	cobalt violet
burnt sienna	cobalt violet deep
burnt umber	cobalt violet light
Van Dyke brown	chrome green
vermilion	permanent green light
cadmium red light	viridian green
cadmium red medium	green earth
cadmium red dark	ivory black
rose madder	lamp black
light red	titanium white (1 pound tube)
alizarin crimson	flake white (1 pound tube)
Indian red	zinc white (1 pound tube)

Oil paints are at their peak of natural adhesion when they come from the tube. The longer they are exposed to the open air on the palette, the weaker their adhesiveness. In order to retain the natural adhesiveness of the paint, you should always use fresh paint and avoid leaving large remnants of color on the palette.

Mediums

Oil paints straight from the tube are generally too stiff to manipulate effectively. To make the paints more fluid, we combine three ingre-

dients: turpentine, linseed oil, and stand oil.

If you use turpentine too profusely, you will destroy the binding properties of oil paint, so use rectified turpentine either to thin or to extend your oil colors, but only when you *begin* a painting. This will produce a matte surface, an undesirable quality because the flat surface collects dust and is impossible to clean effectively. For this reason, use turpentine only to block in the shapes of your composition.

When you're ready to apply the second coat or the successive layers of color, use your painting medium in a combined mixture of $\frac{1}{3}$ linseed oil, $\frac{1}{3}$ rectified turpentine, and $\frac{1}{3}$ stand oil. With this medium, you can extend your oil paints to give you a glossy surface, the chief characteristic of an oil painting. This glossy surface indicates that the pigments are properly bound by the oil medium; the surface is smoother and more resistant to atmospheric attacks. (Never use damar and mastic varnishes, because these are resin-based and too soft to clean properly.) Use copal varnish or stand oil, thinned with rectified turpentine, for glazing and overpainting; these will not yellow or crack.

A heavier medium (with no turpentine added) produces a higher gloss enamel-like finish, which enhances the tonal values of your painting, promotes the blending and fusing of colors. (Oil paints straight from the tube will not blend readily and, when used in profusion, will smear easily, rather than flow into one another.) A heavy medium permits frequent overpainting, without impairing the permanence of the paint film.

Cobalt drier

Cobalt drier is a liquid which hastens the drying of oil paints. Add it to colors as well as to the medium. One or two drops of this powerful drier added to one inch of paint, and one drop to a teaspoonful added to the medium will make the painting dry in a matter of hours, rather than days. Apply the paint to the canvas thinly; otherwise, it will dry quickly on the surface but will remain wet below for a long time.

Canvas

The most common support for oil painting is canvas, either linen or cotton duck. Buy an already-primed canvas, the surface of which has been coated with a thin size glue and white lead priming. A heavyweight canvas is best for heavy paint; a lightweight canvas is preferable for thinner painting. The more impasto you intend to use, the

greater the need for a heavyweight linen canvas, because you'll need more strength to support the weight of the paint layers applied on the surface.

In any case, it's important that the support (or ground) has some degree of tooth or roughness. This kind of surface takes the paint from the brush and permits you to control the brushwork more easily; free brushwork is difficult on a smooth or slick surface. Moreover, the rough surface insures good paint adhesion. For heavy painting, use a coarse tooth weave; for thin painting, use a fine tooth.

Brushes

For the purposes of this book, you'll need only bristle brushes, the best all-around brushes for any painting with opaque colors, and a few sables. Bristles come in three categories: *flats* (over-long bristles, with a great deal of spring, ideal for detail and general work); *brights* (short, blunt hair lengths, best suited for quick transfer of as much paint as needed from palette to canvas); *rounds* (stiff and rigid, ideal for scumbling, scrubbing, glazing, and dry-brushing). Be sure you own a variety of sizes in each category. These should serve you well in the exercises.

Palette knives

In some exercises, particularly those involving the impasto technique, you'll need palette knives to apply the paint. There are two types, and I suggest you get at least one of each: flat-handled, spatula type blade, used for mixing colors on the palette; trowel shape for distributing large quantities of paint onto the canvas.

Additional tools

I've given you the basic equipment you'll need. Here are related materials you should have on hand as well.

knee-length smock
metal or wooden paint box, 12″ x 16″, with wooden palette fitted into the grooves of the lid
many paint rags (worn-out sheets will do)
two large oil cups for your mediums

Tools for collage

Since so many of the exercises in this book are in collage, here's a list of materials you'll be needing as you work:

one jar of Elmer's glue

one safety razor blade for cutting paper

one package of 10″ x 12″ construction paper in assorted colors

one 18″ x 24″ and one 16″ x 20″ Masonite panel, ⅛″ thick, untempered. (I recommend this because it resists different room temperatures and does not warp or stretch out of shape.)

several sheets of colored, transparent papers.

any flat materials that strike your fancy, such as fabrics, plastics, leather, colored photographs, transparent colored tissue papers or gelatin.

any textured materials you prefer, such as twigs, feathers, corn, leaves, kernels, seeds, string, embroidery threads, sand, gravel, fur, bark, etc.

one 12″ ruler

a pair of sharp scissors

With these materials on hand, you are prepared to undertake any of the exercises in this book. Lay them out before you, so that you won't have to hunt for them while you're in the throes of painting or pasting.

Exercises to get started

The exercises in this chapter will give you some idea of the general characteristics of color. These exercises will explore the primary colors; the mass tone, undertone, and half-tones of all the colors; prepare you for learning the different variations of the same color families; and for using the earth colors. We'll start at the beginning, doing the simpler exercises first, and—as the book progresses—we'll build toward the more complex. The next three exercises will get you started.

EXERCISE 1: EXPLORING THE PRIMARY COLORS

Your primary colors are red, yellow, and blue. From these three colors, all the other hues are derived. It seems obvious that the first step in seeing color is to explore these primary colors.

TOOLS: canvas board, 18″ x 24″
assorted brushes

COLORS: cadmium red
cadmium yellow
cobalt blue
ivory black
titanium white

Let's do a painting using only the three primary colors in their pure state, as they come out of the tube. This is a good way to become familiar with them, and—more important—is a good way to observe how these colors can influence each other, depending on which colors they've been placed next to. Remember, all your other colors are obtained by different mixtures of these three, so you should get to know them first.

First squeeze ample amounts of each color onto a clean palette, then —using a clean brush for each color—place a large blob of paint in key spots on the canvas. Next, add pure white next to each primary color, allowing the white to blend slightly into the color. Extend the color area of each hue so that they now almost touch one another. Finally, take pure black and enclose each shape with a direct, bold brush stroke.

Step back and study your finished canvas. Note how the black gives added vibrance to the colors and observe how they relate. Which shape looks largest; which looks the smallest? Which area is the liveliest; which the dullest?

Now take all three primary colors and mix them together. Notice what an interesting gray you get from this mixture.

EXERCISE 2: EXPLORING THE MASS TONES, UNDERTONES, AND HALF-TONES

Let's not concern ourselves with subject matter just yet; we're going to concentrate on the physical qualities of the colors themselves.

TOOLS: three 16″ x 20″ canvas boards
palette knife
assorted brushes

COLORS: all the colors in your paint box

On the first canvas, you'll do a painting in the mass tones; that is, the colors as they come straight from the tube. First squeeze out a little of each color onto the palette and then, with your knife, apply each in fairly large dabs to your canvas. After you've applied all the colors, you have a complete array of pure colors which you can refer to from time to time as you do other work.

On the second canvas, you'll lay out all the undertones. These are the colors mixed with white. Systematically taking each color one at a time, mix it with white on the palette, and then apply it with your

knife to the canvas. Now you have a complete array of all the *under-tones*.

On the third canvas, lay out all the half-tones, the colors mixed with a little black. Apply these colors in the same way you applied the mass tones and undertones, and you'll have three canvases which you can use for reference.

EXERCISE 3: VARIATIONS WITHIN THE COLOR FAMILIES

Later in this book you'll be studying color values, the amount of light or dark in a color. Just to give us an idea of what variations are possible with individual colors, let's do a series of six paintings, each in a family of one color, in order to obtain a variety of gradations. This exercise will help you see how many gradations you can make by taking one color from its lightest to its darkest extreme.

TOOLS: six 16″ x 20″ canvas boards
assorted brushes

COLORS: cadmium yellow
cadmium red medium
cadmium orange
cobalt blue
viridian green
cobalt violet
ivory black
titanium white

Paint one canvas at a time. First cover the entire surface in a single hue. Then, with a clean, dry brush, mingle a little of the white on the *upper edge* of the canvas and work it into the wet color underneath, until it forms a new light color. With another clean, dry brush, work a very little amount of black into the *lower* portion of the canvas, and gradually blend this into the original color. Notice that as you mingle the color with black and white you form several new values. When you've completed all six canvases, you'll see that you have a group of wonderfully poetic ground colors. These canvases can serve as grounds or backdrops for whatever subject material you might like to chose later. You'll find they are especially adaptable for landscapes.

Throughout this book, you'll be using so-called earth colors, paints prepared from ores and oxides found in the earth. In this exercise, we'll see how these colors can serve you.

TOOLS: assorted brushes
 canvas, 16″ x 20″

COLORS: raw umber
 Van Dyke brown
 raw sienna
 burnt sienna
 Indian red
 green earth
 yellow ochre

Whenever you wish to reduce the brilliance of a color without diminishing or eliminating its color content, you can use the earth colors. If you place an earth color next to or mixed into a bright color, you'll accomplish this end. For example, to reduce the brilliance of yellow, place yellow ochre alongside the bright yellow; to reduce an orange, use raw umber or Van Dyke brown; to reduce a blue, use raw sienna; to reduce an orange, use burnt sienna; to reduce cadmium red, use Indian red; to reduce a green, use green earth.

The entire color scheme in a painting will be muted when you substitute an earth color for a pure color. To create a more subtle effect, use earth colors unsparingly. For example, instead of using cadmium yellow, you can use yellow ochre, raw sienna, or raw umber; rather than viridian green, you can use green earth; for any of the blues, you can use raw umber and grays. Then, for supplementary color accents, you can use colors that you haven't used elsewhere in the picture.

In addition to making your colors subtle, earth colors also help the painting to hang together, giving it a sense of unity. Try a painting in earths, and see for yourself.

Paint the entire surface of a dry canvas with one of the earth colors thinned with turpentine. Next, wipe out this ground color in the places where you wish to let some bright color come through. While the paint is still wet, superimpose your subject, say a landscape, also painted in earth colors. You can achieve a feeling of unity by adding

some earth color to each of the bright colors before you apply them to the canvas. When you've almost finished, add a bit of fresh color to the highlight areas in order to perk things up.

EXERCISE 5: ACHIEVING A PLASTIC QUALITY

In the last exercise, we achieved a subtle color effect. Here we will work with the bright colors to see how we can achieve an *electric* effect.

The plastic quality in a painting is the tension created between one element and another, the "push and pull" in a composition, achieved when the pure colors are juxtaposed to one another. The German expressionists and the abstract expressionists were concerned with obtaining this plastic quality. And, in this exercise, so are we.

TOOLS: canvas, 24″ x 30″ or larger
six large brushes
two medium sized brushes

COLORS: cadmium yellow
cadmium red
ultramarine blue
cobalt violet
cadmium orange
viridian green
ivory black
titanium white

First, squeeze out fairly large amounts of your colors onto the upper edge of a clean palette. Using a separate brush for each color, apply the paint to the canvas in large, massive strokes so that they almost touch each other. Place them alongside one another until you've covered the entire surface of the canvas. Keep in mind the single purpose of this exercise: to study the effect that the pure bright colors have on one another. Any literal subject matter would distract you from this objective. That is why I suggest you think in terms of an over-all pattern of pure colors going in either a rectangular or spiral action on your canvas. After you've applied all the colors, place touches of pure black or pure white wherever you feel the need for a slight accent or emphasis.

It's a good idea to paint standing up, in order to allow for greater freedom of movement. You'll find that painting in this manner is a great release and allows for much freedom of expression when you're in a carefree mood. Better still, you'll find that by placing these pure colors alongside each other the over-all effect is more exciting. Their interaction creates the scintillating and electric effect we call plasticity. To alter any one part would disrupt the chain-reaction of the movement in the painting.

These three exercises have helped to get you started. By now you should be loosened up, and ready to explore some of the characteristics of color in greater detail. Are you ready?

2 COLOR TEMPERATURE

Let's start with *temperature,* in which colors fall into four categories: hot, warm, cool, cold. Here's a list of these colors which you can refer to from time to time.

HOT
- flake white
- cadmium yellow
- cadmium red medium
- cadmium red light
- burnt sienna
- yellow ochre
- ultramarine blue
- cadmium orange
- lamp black

WARM
- Naples yellow
- chrome green
- permanent green light
- cadmium red
- cobalt violet
- Venetian red
- cerulean blue
- green earth
- ivory black
- titanium white

COLD
- Prussian blue
- cobalt violet deep
- raw umber
- zinc white
- ivory black
- gray

COOL
- alizarin crimson
- viridian green
- cobalt blue
- cobalt violet
- light red
- lemon yellow
- gray
- zinc white

What is color temperature?

When we describe colors as *warm* and *cool,* we're not referring to the physical, but to the esthetic qualities these colors possess. You can understand this point by thinking of what the words warm and cool

suggest. For example, let's say *hot* suggests fire. When you utter the word *fire,* the colors that come to mind would be the reds, yellows, and ultramarine blue, in their purest state, right out of the tube. Similarly, the colors that come to mind at the mention of "a cold ocean wave" would be Prussian blue with white added, gray-greens, and black and white. However, not all the blues are cold: for example, cerulean blue has a soft greenish cast and appears quite warm when placed next to the Prussian blue, which is cold. However, all the reds are warm—even cool alizarin crimson is warm when placed alongside any blue. The degree of warmth and coolness of colors depends not only on their inherent quality, but on two other factors as well: how you place them alongside each other and what you mix them with when you modify or accent their temperatures. For example, lemon yellow is only cool when placed next to warm cadmium yellow. The same lemon yellow will be considered *warm* if placed next to Prussian blue. Alizarin crimson, when mixed with white, is quite *cold* when seen next to the peaches-and-cream cast of a cadmium-red-plus-white combination.

The basic hot colors are the cadmiums—the cadmium reds, yellows, and their derivatives. Furthermore, a little ultramarine blue, when mixed with the cadmium yellow, gives you a hot yellow-green and, when mixed with a cadmium red medium, gives you a hot purple. The colors we refer to as hot are so because they are more intense and dynamic in their pure, right-out-of-the-tube state. These same colors, however, become simply warm the moment you lighten or darken them.

EXERCISE 6: "GETTING TO KNOW YOU" EXERCISE

But get to know color temperature by actually doing just what I have been describing above. The following is a random exercise and will act as a springboard for getting you started with something that won't take *too much preparation!* The purpose of this exercise is to merely introduce you to some of your colors and, to a limited extent, show you how they change depending on which colors they have been placed next to.

TOOLS: canvas board, 18″ x 24″
peel-off paper palette
trowel-shaped painting knife
flat-blade scraping knife for mixing

COLORS: cadmium red light
 alizarin crimson
 lemon yellow
 cadmium yellow medium
 cerulean blue
 ultramarine blue
 cobalt blue
 Prussian blue
 green earth
 viridian green
 raw umber
 ivory black
 titanium white

On the upper edge of your palette, squeeze out one-inch dabs of colors so that they are placed in a horizontal row, one next to the other. In all color mixing, always start with a weaker color, gradually adding small amounts of the stronger one until you get the color you want. When white is added to a color, its purest value is revealed. Therefore, before embarking on any color exercise, it's a good idea to first mix the said color with a little white in order to judge what you are working with.

Using your trowel-shaped painting knife, apply the paint in patches onto your canvas in this sequence:

First, place a patch of cadmium red next to cadmium yellow medium. Mix some of these two colors on your palette. You now have a *hot* orange. Place this alongside the red and yellow.

Next, take a mixture of white plus raw umber. Place it next to the three colors you already have on the canvas. Then mix the raw umber and orange and place this mixture next to the others. Note how much hotter this last mixture is in comparison to the others.

Now take lemon yellow and place a patch of it next to cadmium yellow; note how *cool* lemon yellow seems when you place it alongside *hot* cadmium yellow. Next take lemon yellow and place it next to Prussian blue which has been mixed with white. Notice how the lemon yellow now appears *warm*.

Alizarin crimson, plus a little white, has now become pink and when placed next to cadmium red will appear *cool*. Cerulean blue is *warm* placed next to *cool* cobalt blue. Ultramarine blue is *hot* next to *cold* Prussian blue. Green earth is *hot* next to *cool* viridian green.

Upon completing the above series of steps in the "Getting to Know You" Exercise, you now have a very general idea of how your colors vary when they are placed alongside different colors. Now you should be aware that alizarin crimson is your coolest red, cadmium yellow medium is quite hot, and lemon yellow is cool. You've seen that cerulean blue is warm, viridian green is cool, and raw umber can be either cool or warm, depending on what it is mixed with. In short, you now have a good general idea of *how colors can change,* depending on what company they keep! Now that you've seen the general characteristics of color temperature, let's examine the qualities of individual color groups. In the next exercises, you will be dealing with only one temperature area at a time.

EXERCISE 7: MEET THE HOT COLORS

We will begin by studying the tonal scale of the hot colors. In the next exercise you'll learn how to distinguish the subleties, nuances, and variations the hot colors can produce by the *amounts of other colors you mix them with.* It is really a color mixing exercise, and once you have familiarized yourself with these mixtures, you'll be able to repeat and match them at will. I suggest you use two separate palettes, one on which you do your mixing, and the second on which you'll *lay out* your colors in a systematic order so that you can easily keep track of them, and will also be able to examine their tonal values.

TOOLS: two palettes (one for mixing and one on which you arrange the mixed colors)
1 spatula-shaped knife for mixing

COLORS: cadmium yellow medium
cadmium red light
cadmium red medium
cadmium orange
yellow ochre
ultramarine blue
flake white
lamp black
burnt sienna

On the upper edges of your painting palette, squeeze out two-inch dabs of each color listed above.

Squeeze out two more rows of the nine colors in exactly the same sequence as above so that you now have three rows of colors running across the palette in a horizontal line. The first row will be the pure color as it comes out of the tube, the *mass tone*. To the second row, add a little white to each color, giving you its *undertone*. To the third row, add a little black to each color, bringing out the *half-tone*.

Now, on your extra palette, mix cadmium yellow medium and a little ultramarine blue together, in order to make your *hot* yellow-green. Next, mix cadmium red medium, plus a little ultramarine blue with a little white, and you will have a *hot* red-violet. Place these two new mixtures onto the painting palette under the last row of the other colors. You now have a full tonal scale of hot colors. Do you think you can distinguish them easily?

EXERCISE 8: PAINTING A HOT PICTURE

In this second exercise with the hot colors, you'll be able to use up the colors you've just mixed on your palette. Besides these colors, you'll need these supplies:

TOOLS: canvas, 24″ x 30″
flat bristle brushes, two of each: nos. 2, 4, 6, 8; one of each: nos. 10, 12

Try to visualize a hot, atmospheric setting, because this is to be a painting which suggests a hot mood. For your painting, choose a subject that will provide or allow you to break up your picture area into as many shapes as possible. I suggest a pattern-like composition based on an abstract view of an interesting object—say an exotic jungle flower, fruit, or plant. Fill up the picture surface with many variations of this form. Change the form as many times as possible, making it either immense or tiny; have it overlap or go behind other variations; isolate it; make it disappear into the background. This will provide you with sufficient opportunities to use up the colors you've so carefully mixed in the previous exercise.

Use a clean brush for each color and apply the paint with visible brush strokes. Be sure to mix enough paint to cover the area you're working on. Keep your edges sharp and clean so that each area is

distinct from its neighbor. When you've finished, you should be able to identify each variation of your hot colors and know exactly what you did to obtain the various hues.

Now is the time to sit back and study the finished painting. Do you like it? Is it successful? Have you expressed a hot mood? The answers to these three questions will all be in the affirmative if you followed the exercise accurately.

EXERCISE 9: COLOR MATCHING TEST

Now test yourself to be sure you can match those hot colors you used in the painting in the last exercise. For this exercise, you'll use the same colors and brushes you used in the previous exercise, and a clean canvas, size 18″ x 24″.

Select one area of the finished canvas and try to recapture the same hue by remixing its color. See how well you can match them on your palette first, then transfer the mixture to the canvas. In matching colors, bear in mind that you start first by choosing the nearest hue to the one you want to repeat, and then you modify it by adding one to three of the colors you used previously. For example, if you're matching a brownish red, start first with the red and then add the black. Never mix more than three colors together at a time; more will give you mud! Fill up the canvas with colors you have mixed to match those in your last painting.

EXERCISE 10: DIRECT PAINTING EXERCISE

And now for some fun! Let's paint a picture based on what you have learned so far from the last two exercises.

TOOLS: same as in previous exercise, plus painting medium, clean canvas board, 18″ x 24″

Sketch an imaginary landscape on your clean canvas. This time mix your colors directly on the canvas rather than on the palette. Allow the colors to run or fuse together by using your painting medium on your brushes, along with the paint. Work directly on the canvas. The result obtained depends on the proportions of each ingredient in the mixtures. Obtain the hues you want by your own experimenting. Do you now feel you can obtain the mixtures you want easily, so that you can use them swiftly as you paint?

EXERCISE 11: GETTING TO KNOW THE COLD AND COOL COLORS

Just as you learned about your hot colors, you will now learn that the relationships within the cold family also depend on the influence one color has on another. Some cool colors will appear warm or cool, depending on what you mix them with and what their relationship is to adjacent colors. This is another random exercise and will be in the nature of a warm-up, a means of acquainting you with the different temperatures within the cold family. So let's warm up with a "cool" exercise!

TOOLS: clean canvas board, 12″ x 16″
 1 trowel-shaped palette knife for painting
 1 flat-bladed knife for mixing colors

COLORS: zinc white
 ultramarine blue
 Prussian blue
 cobalt violet
 cobalt blue
 cerulean blue
 viridian green
 ivory black

Let me repeat: in all color mixtures, it's always necessary to start with a weaker color, and gradually add small amounts of the stronger one until you get the desired color. For example, first white, *then* ultramarine blue.

Place a dab of white on the canvas with your knife. After cleaning your knife, add ultramarine blue to part of the dab, mixing it into the white. (Use zinc white in mixtures of your cold colors, because this white makes your colors incline a little more toward violet, giving you clearer tints. Use titanium when working with the warm colors. Since this white enhances the soft warm tones of your mixtures, it retains its whiteness to an exceptional degree upon exposure to impure air and it has a great covering power.)

Clean your knife and do the same with the Prussian blue. Study these two colors and you will see that the ultramarine will glow with warmth when compared to your icy-cold Prussian blue.

Make another dab, now with your viridian green. Add white to it

in the same way and you will see how cool it really is. Cobalt blue is a cooler, purer blue, as you will see when you place it alongside cerulean blue, a blue which has a warm, greenish cast. Of course, your mixtures depend on the different proportions added together. The exact shade you require depends on how patiently you do your mixing.

From this exercise you have learned to distinguish your cool colors from one another and how they change, depending on which colors they have been placed next to.

EXERCISE 12: PAINTING A COOL PICTURE

Try to visualize a cool atmospheric setting for this exercise, a painting that suggests a cool mood. In order to explore your world of cool colors, you can work out the composition in a rough, random, expressionist manner, but you must make a point of keeping track of your mixtures.

TOOLS: canvas, 24″ x 30″ (larger if you like)
brushes, two of each: flat bristle nos. 6, 8, 10, 12
turpentine
linseed oil
rags for cleaning
palette
palette knives

COLORS: violet
viridian green
raw umber
cobalt blue
light red
Prussian blue
zinc white
ivory black

Prepare your painting palette in the same way you did in the previous exercise, three horizontal rows of color. First row, the pure colors only (mass tone); second row, the color plus white (undertone); third row, color plus black (half-tone). When you begin to paint, use your colors pure, as they come from the tube. Then, after you've blocked in the pure colors, you can apply the previously mixed variations into the edge, thereby creating more delicate gradations of the pure color.

Mix each color with separate proportions, using lots of zinc white, ivory black (very little goes a long way), and raw umber. For example, a good cool gray is made from mixing together cobalt blue and the earth color called light red—try it!

For subject matter, think of undersea, marine forms. Don't be literal —the aim is to create an atmosphere of a cold, remote place. Try to create a rhythmical composition, using flowing shapes to create your movement. The space between your forms will give you this rhythm.

First sketch in your images; then paint in all your large spaces. I suggest blues and greens for these areas, interspersed with the extreme light colors to suggest wave rhythms or ripples. Next, paint in the small forms, such as fish, seaweed, or vegetation, using colors sharply contrasting to your background colors. Lastly, add details, using a small brush and black. The resulting picture will be a good example of a cool mood.

EXERCISE 13: AND THE WARM COLORS

And now a word about the *warm* colors. These are relatively the same as the ones you used for painting a hot mood, with the exception that they are neutralized and more subtle versions of those colors. In other words, the red will be one that has been lightened by the addition of either white or one of the yellows, made neutral by adding a little raw umber, or made darker by adding a little black or blue. The cadmium yellow becomes warm in the same manner, as do the blues when you add a little yellow.

Let's paint a warm mood, using an imaginary still life for a subject. Select objects that are related to one another; for example, a lantern with sea shells or wine bottle with assorted fruit. In other words, use objects that are in harmony with each other.

TOOLS: clean canvas, 24″ x 30″
brushes: flat bristles, one each: nos. 2, 4, 6, 8, 10
linseed oil
turpentine

COLORS: cerulean blue
cadmium yellow
cadmium red
permanent green light

cobalt violet
green earth
Venetian red
Naples yellow
ivory black
titanium white

Lightly sketch in the outside edge (the contour) of the objects. After this, forget the set-up and work purely from the imagination, using all your warm colors in a way that expresses a warm mood. Your basic warm colors are different from the hot ones by being lighter.

Prepare your painting palette by squeezing out first one horizontal row of your pure mass tone colors. Then make a second row: the colors plus white (the undertone); then the third row: the colors plus black (the half-tone). Use a clean brush for each color and apply the paint with visible brush strokes. Be sure you've mixed enough paint to cover the area you're working on. Keep your edges sharp and clean so that each color is distinct from the one it's next to. Remember, you're expressing a warm, languid mood, so brush on the paint with loose strokes. Paint in the largest shapes first, then the smaller ones, and finally the small details, using a very small brush.

When you've finished, you should be able to identify each variation without any trouble. You can now sit back and scrutinize the finished painting and it should be quite successful; that is, if you were guided by the directions.

EXERCISE 14: FOR A VERY COLD MOOD

Create a composition based on one form without details: a face or a figure ice skating, for example, and then repeat the form, or parts of it, within your picture. Isolate the form, interrelate it; see how many aspects of this single object you can create by using your brushes and palette of cold colors.

TOOLS: clean canvas, 24″ x 30″
bristles brushes, one each: nos. 2, 4, 6, 8, 10
linseed oil
turpentine

COLORS: viridian green
Prussian blue
cobalt violet deep

raw umber

grays

ivory black

zinc white

Prepare your painting palette in a way similar to the other exercises, with three rows of horizontal colors. First row: the pure colors as they come from the tube (mass tone); second row: the colors plus white (undertone); third row: the colors plus a little black (half-tone). For the gray mixtures, mix three cold grays: zinc white plus a little black; zinc white plus viridian green and black; zinc white plus violet and black.

Use your cold gray mixtures to paint the ice skating rink and surrounding countryside. Next, paint in the sky area, using a lightened version of the Prussian blue. Lastly, paint in the skaters, using either extreme dark or extreme light colors (black and white are fine for this), along with any of the fine detail work you may wish to add.

If you've been careful with your color mixtures, your completed picture should suggest a cold, winter scene.

EXERCISE 15: COMBINING WARM AND COOL

Now let's try a painting that combines everything we've learned about both the warm and the cool colors. This way you'll see how the colors react to each other and give you the maximum benefits of color temperature.

TOOLS: canvas, 24″ x 30″

peel-off paper palette

trowel-shaped painting knife

spatula-shaped palette knife for mixing

COLORS: cadmium red light

Naples yellow

raw umber

cobalt violet

lemon yellow

cerulean blue

green earth

ivory black

titanium white
alizarin crimson
cobalt blue
cobalt violet
light red
raw umber
ivory black
zinc white

Consider a painting that has two separate fields of color areas. A landscape lends itself nicely for exploring this idea. You would use your warm colors for the foreground and the cool colors for the background. Think of your subject in terms of receding and advancing areas, so that you won't be confused. For example, in the receding field, you use the cool colors; for the advancing forms, you use the warm ones. Of course, you needn't use every single color on your list. Select the ones you like best from each of the two temperature areas. Paint in the largest spaces first, because these establish the mood of your painting. After this is done, superimpose the details—such as trees, houses, people—then put in your shadow areas, and the highlights. Don't overload your picture with little details, because this will tend to make your composition spotty.

Your painting should be a rich variety of color temperatures.

Some concluding remarks

Now that you have completed the ten exercises in this chapter, you should have a good idea of how the temperature of colors varies when they are mixed in different ways and placed alongside different colors. You have also learned to distinguish the subtleties, nuances, and variations the colors can produce by the amounts of other colors you mix them with. You have familiarized yourself with these mixtures and should now be able to repeat and match them at will.

I hope you have also learned some important painting habits. You should understand the importance of preparing your colors beforehand and placing them in systematic rows on your painting palette so that you can identify them without getting confused. And you know enough now to always give yourself plenty of time in which to both prepare your palette and to use up whatever colors you have previously mixed in order to paint a successful picture.

3 THE COMPLEMENTARIES

When we refer to the complementaries we mean colors that are opposite in character in the sense that these colors appear opposite to each other on the basic spectral circle, or the so-called "color wheel." (See next page.) Starting with the basic primary colors, for example, the complement of red is green; the complement of blue is orange; and the complement of yellow is violet.

To achieve harmony with these colors, the complementary should be in the same temperature scale as its primary color. Remember this rule: *warm for warm and cool for cool.* For example, for *warm* cadmium red, the complement is a *warm* yellow-green; and for *cool* lemon yellow, the complement is a *cool* pink violet; for *warm* cerulean blue, the complement is a *warm* yellow orange. But try your own combinations. Just remember the rule: to achieve harmony when mixing your complementary colors, use warm for warm and cool for cool.

EXERCISE 16: LAYING OUT THE COMPLEMENTS

Just as we laid out the colors to understand the variations of temperature, we'll begin here by laying out all the complements.

Tools: assorted brushes
 canvas, 16″ x 20″

To better facilitate matters, I've prepared a list of primary colors and their matching complementary partners. For a warm-up exercise, paint square splotches on a small canvas, and arrange them in the order I've listed so that you can see the actual colors and their partners.

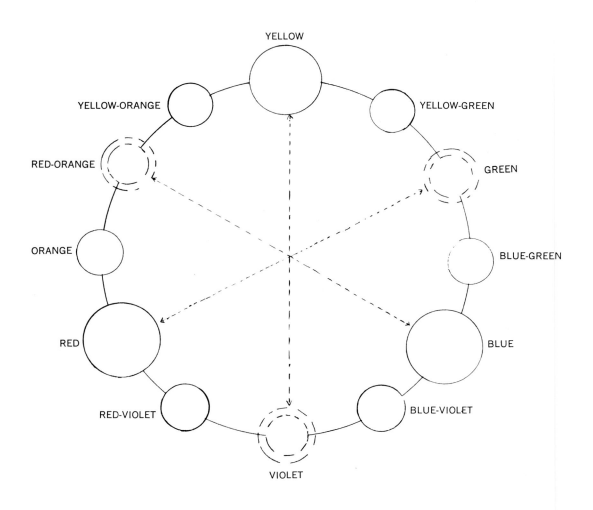

	PRIMARIES	COMPLEMENTS
YELLOWS	lemon yellow	pink violet
	cadmium yellow	cobalt violet
	yellow cadmium deep	cobalt violet deep
REDS	cadmium red or vermilion	yellow-green or permanent green light
	cadmium red light	yellow-green
	cadmium red deep	viridian
	alizarin crimson	green earth
BLUES	cerulean blue	yellow-orange
	cobalt blue	cadmium orange
	ultramarine blue	red-orange
	Prussian blue	cadmium orange

After completing this exercise, you should be able to see which of the complementary colors harmonize. You've learned that even though certain colors are opposite one another on the color wheel, they can harmonize nevertheless. This is a fascinating contradiction of terms and one you should remember. Therefore, hold onto this canvas in order to study the different combinations and in order to refer to them from time to time.

EXERCISE 17: WHEN DO THEY VIBRATE?

When you place a primary color next to its complement you'll find that both colors suddenly come alive. The stress of interaction is what creates this tingling scintillating effect. For example, you'll note that when you place a red alongside a green, or a blue next to an orange, or yellow near a violet, you'll achieve a mood that vibrates with life in your canvas. Let's do a painting exploring this idea and see what takes place.

TOOLS: canvas board, 20" x 24"
palette knives

COLORS: vermilion
veridian green
cadmium yellow
cobalt violet
cobalt blue
cadmium orange

I suggest you create a composition using abstract shapes with well defined edges, shapes having no resemblance to recognizable objects, since we want to concentrate on color alone, without being hampered by subject matter. The traditional abstract shapes are those resembling a circle, square, or triangle. Fill up the canvas with as many forms as you have colors—six in all—and place all three primary colors and their respective complements near each other. Sketch in your composition with a thinned wash of any one of the colors. Overlap the forms, or place them behind one another, or isolate them. In short, sketch in an over-all composition, using abstract shapes, being as inventive as possible. For reference, think in terms of a mosaic panel, or a tile wall. These should help you visualize the end result!

With your trowel-shaped palette knife, applying each color in broad, flat strokes, take care to keep the edges of each form crisp and clean. Place the colors so that they appear as partners—next to, above, or below one another. In other words, place red with green, yellow with violet, and blue with orange. Do this until you've used up all your colors. The finished picture produces the marvelously vibrant array of colors that artists call "plastic quality" in a painting, caused by the vibrations of primaries juxtaposed with their complements.

EXERCISE 18: PLASTIC QUALITY IN A LANDSCAPE

Like the German expressionists (Franz, Marc, and Jawlensky), you can create scintillating effects by selecting colors which electrify each other. Let's try it.

TOOLS: palette knives
canvas, 24″ x 30″
assorted brushes

COLORS: cadmium red
cobalt blue
permanent green light
cadmium orange
ivory black
titanium white

Place a hot color next to its opposite cool partner. Try it and see if it's not true. You'll find that the stresses of interaction cause each to tingle and to scintillate. Select two colors: for example, use red and blue and their complementaries, green and orange. Cover your canvas with these four colors, each one in a large space, using a trowel-shaped knife to lay in the paint.

Step back and look at the work you've done. If an area looks like a tree, a house, a mountain, or a person, refine the form by using a little black paint on the edge of the knife to make the shape identifiable. (You can even use a smallish brush to do this.) Now decide on a source of light and indicate this by blending some white into these areas. Finally, place touches of pure black or pure white (or a combination of both to make a basic gray) wherever you feel a shadow area should be. Whatever you do, don't use too much of the black or white, or

you'll run the risk of neutralizing all the brilliancy of your painting!

By having used colors that are opposite to one another on a single canvas, you created a series of tensions that encourage the eye to shift back and forth, from one color to another, thus creating the "push and pull" quality in your painting. In other words, it jumps with the life that painters refer to as plasticity.

EXERCISE 19: WHEN DO COMPLEMENTS CANCEL EACH OTHER?

When a color is of a lighter hue, it always looks larger than it really is; therefore, when you place a light color next to its complement, the lighter one will assume more importance and will cancel out its darker companion. The next exercise will show you how this principle works.

TOOLS: assorted brushes
stretched canvas, 24″ x 30″

COLORS: cadmium yellow
vermilion
cobalt blue
viridian green
violet
cadmium orange

For a subject, I suggest landscape forms without details. In sketching your composition, break up the picture surface into broad sections, organizing your forms in terms of planes and masses of shapes that are characteristic of a country landscape: i.e. sky, hills, fields, barns, lakes, etc. You should plan at least six major areas so that you utilize all six colors.

Now you're ready to paint! Apply the colors wherever you feel like putting them, using broad, flat strokes. Keep the edges of your different areas well-defined.

When you've finished, study your canvas from a distance and see what is meant by "canceling out." Broadly speaking, this describes the effect of one color taking prominence over another. As a rule, the lighter and brighter color will cancel out a complement, if its partner is of a more somber value, because the lighter color always seems to enlarge the space it occupies and, in so doing, will project the mood that is characteristic of that particular color. For example, yellow will

cancel out violet, orange will take prominence over blue, and red over green. This happens even when the area covered is larger than the lighter color area.

Now look at your finished painting. You'll note that the sections painted in yellow cancel out all others. Next, orange takes over, followed respectively by red, then blue, then violet, leaving green last of all. Therefore, it's a good idea to remember that although complementary colors vibrate when they are placed next to one another, a lighter and brighter color will also cancel out its complementary partner when that partner is of a darker tone.

EXERCISE 20: HOW DO COMPLEMENTS REACT WHEN JUXTAPOSED?

When complementaries are justaposed, they not only vibrate and cancel out each other, they also create definite rhythms. This is best illustrated by the paintings of Vasily Kandinsky or Attilio Salemme. When these colors are laid out side by side, you'll notice that light and dark colors follow each other in sequence and this beat of "light, then dark" creates a certain rhythmic effect. Therefore, when you wish to create a highly jumpy mood in your painting, use primary colors with their complementary colors next to them. Let's put this principle to the test in this exercise.

TOOLS: assorted sable hair brushes
 canvas board, 16″ x 20″

COLORS: vermilion
 viridian green
 cadmium yellow
 cobalt violet
 cobalt blue
 cadmium orange
 ivory black

For a subject I suggest an over-all pattern of geometric shapes. Using a soft pencil—you may also want to use a ruler—sketch in your design carefully. You'll find that using pure abstract forms enables you to study the color effects, without being distracted by classic subject matter.

Now paint in your colors. Use them in sequence according to their

corresponding complements, interspersed with pure black or white areas. The finished picture should be a highly-charged, dynamically rhythmic mood!

One family at a time

The purpose of the forthcoming series of exercises is to teach you to recognize and observe how pure colors change when they are mixed with a complement. These exercises will keep you occupied for a full week. I say this to prepare you beforehand, because it's necessary that you do the exercises in sequence and to stay with your work from start to finish without interruption. At the end of one week you'll have completed a series of five paintings. Each painting will be in the family of one color with its corresponding complementary color.

Monday: All the blues—with orange

Tuesday: All the reds—with green

Wednesday: All the yellows—with purple

Thursday: All the grays—with red, blue, and yellow

Friday: Riot of colors day!

These exercises are not meant to be world-shattering masterpieces, so work patiently and systematically. Someday you may very well create the painting of paintings and the best way to realize this goal is to plug away at your exercises, in order to gain the necessary experience.

For subject matter, I recommend the use of abstract shapes whenever possible, because this provides the best opportunity for breaking up the picture surface many times, thus giving you a valid reason for using up the numerous mixtures of colors. By painting in these colors next to each other, you can readily see how the primary colors have been affected by the addition of their complements.

EXERCISE 21: CALMING THE COOL BLUES WITH ORANGE

When one color is mixed with its complement, the result is usually a neutralized color, a color that is "calmed" down. Therefore, the purpose of this exercise is to study each blue color in its pure state to see what happens when mixed with its complement, *orange*.

TOOLS: canvas board, 18″ x 24″
 assorted brushes

COLORS: cobalt blue
cerulean blue
Prussian blue
ultramarine blue
raw umber
ivory black
titanium white
cadmium orange
cadmium red
cadmium yellow

For subject matter, I suggest an all-over composition based on one form, without any details; for example, a face, a single figure in silhouette, a vase, or a free form abstract shape. Repeat the shape or parts of it within your picture. Isolate it, interrelate it; see how many aspects of this object you can create. When you have carefully sketched in your subject, prepare your palette of colors, using only the blues. You might squeeze out a little of each blue in a row on the upper edge of your palette, and under these some of the cadmium orange and its two derivatives—yellow and red—plus some raw umber, titanium white, and ivory black. Now you're ready to do your mixing.

Taking each blue, one at a time, separately mix each with a little of the orange, add a little more yellow when you want your orange to warm up, a little red when you wish to temper it down. Another combination is a blue, plus orange and a little black; still another is blue plus raw umber and orange. White added to any of these combinations will give you lighter values. You'll see that the resulting values will be muted, gentle gray-blues. Now you're ready to start painting!

After you've sketched in your composition, proceed by first painting in all your pure blues. Next to each pure area, place some of its calmed-down blue (that is, a blue with the orange added). Do this until you've used up all your colors. The resulting picture should be a muted creation, suggesting a gentle calmed-down blue mood!

EXERCISE 22: ALL THE REDS WITH GREEN

Now you're ready to proceed with the next exercise in using the complementaries: red and green. You'll find that an entirely different quality is obtained than the effects in the last exercise.

TOOLS: canvas board, 18″ x 24″
1 trowel-shaped palette knife
1 spatula-shaped palette knife
lots of rags

COLORS: cadmium red light
cadmium red medium
cadmium red dark
alizarin crimson
permanent green light
viridian green

In order to explore the many color variations you're mixing, I suggest you use abstract forms as subject matter. Think of the circle as a point of departure. See how many free-form variations of this round shape you can create. Be as inventive as possible. Fill your canvas with an abundance of spaces and shapes and break up the surface as many times as possible: have the forms overlap, go behind each other, stand alone. Plan as many forms as you have colors. Remember, you want to use all your pure colors as well as those already mixed with the complementary color. So be generous with your forms. After you've sketched in the composition, start to paint by systematically applying first the pure red and then the same red with its complementary green added. Do this until you've placed each of your reds on the canvas. By doing this, you'll have familiarized yourself with the different values produced by your reds, and their complementary partner, green.

EXERCISE 23: ALL THE YELLOWS WITH VIOLET

Now let's try an exercise using the next set of complementary colors: yellow and violet. You may be surprised to discover how many variations are possible with these complements.

TOOLS: canvas board, 20″ x 24″
assorted brushes
palette knife, flat blade for mixing
clean palette
rectified turpentine

COLORS: lemon yellow
cadmium yellow medium

cadmium yellow deep
yellow ochre
raw umber
cobalt violet
ivory black
titanium white

With a thinned wash of yellow ochre and turpentine, sketch in an imaginary still life composed of interesting shapes. Ignore the actual still life colors as they are in real life, since you'll be painting only with yellows anyway. Decide where your source of light will be in the picture and then proceed to indicate the dark sides of the different objects by blocking them in with a thinned-down raw umber.

Now study the different yellows, planning where you'll use them. Start by painting the largest area first—selecting the most neutral of yellows (yellow ochre)—for this purpose. In other words, first select the yellow suitable to a specific object (let's say the apple), then paint in the entire apple with the yellow. Next scrub pure white into the wet paint, to produce the light side. Lastly, scrub some violet into the dark or shadow side.

Follow this procedure with all the different objects until you've used up all the yellows. In this way, you'll be painting in monochromatic harmonies; that is, a picture made by using one color, its complement, and black and white. You'll he surprised how many harmonies you can produce, simply by altering the proportions of your complementary color and white and black.

EXERCISE 24: ALL THE GRAYS WITH RED, YELLOW, AND BLACK

The misleading thing about the term "all the grays" is the tendency to regard gray in terms of black and white mixtures. However, simply by adding, let's say, red to this mixture, you can get a red-gray; by adding blue, a blue-gray; by adding green, a green-gray, and so on. In other words, the variety of *grays* are simply the *basic gray plus any bright color.*

TOOLS: canvas, 24" x 20"
assorted brushes

COLORS: ivory black
titanium white

burnt umber
cadmium red
cadmium yellow
cobalt blue

In this exercise, plan a composition using both amorphic and hard-edge shapes; that is, shapes with a rounded contour and with a straight edge, an abstract composition with no recognizable object.

This is to be a painting using all your grays, but grays that complement one another. In other words, next to a shape which you have painted in a green-gray, place a reddish gray. Next to a yellow-gray, try a purple-gray. Next to a blue-gray, try an orange-gray. Paint until you've covered all your abstract forms. If you should feel it necessary, accent certain areas with some of the pure primary color. Try it and see how you like the effect!

EXERCISE 25: RIOT OF COLORS DAY!

The pointillists were able to simulate the illusion of light by juxtaposing tiny dots of bright colors alongside their complementaries. When viewed from a distance, the tiny dots fuse, the eye of the beholder does the mixing. These daubs of pure color placed next to each other produce fresh and vibrant values unsurpassed by other schools of painters. In the following exercise we're going to follow the example of the pointillists and use all the colors in the paint box.

TOOLS: lots of brushes, all small
palette
canvas, 16″ x 20″

COLORS: all the colors in the paint box

Prepare for your painting session by squeezing out daubs of each of your colors. By this time, you now know which colors complement one another, so you needn't stick with any prepared arrangement. Its a good idea, however, to put all the yellows together, all the reds together, etc., to avoid confusion.

For subject matter, I suggest you plan an imaginary over-all pattern of a bouquet of flowers. Sketch in your design, briefly indicating where the light is to be coming from. Don't lose track of this light in the

throes of painting! You needn't confine yourself to painting tiny dots. You may want to pat on dabs of colors about ½″ in size. For example, when painting a red flower, you can paint the entire flower by patting on vermilion dots, interspersed with some orange and white on the light side. On the dark side, pat in some yellow-green—the complement of vermilion—or blue and yellow—the two colors that make green—alongside the vermilion areas. Use all the colors in their pure states and when you view your painting from a distance, you'll discover that these myriad colors have blended, because your eye is doing the mixing for you. Follow the same procedure with all the other colors. It would be a good idea to consult your complementary list here.

By completing all the exercises in this chapter, you should now have a feeling for the power of complementary colors, how they can be used to envigorate a painting, how they can be used to subdue a painting. This will be very valuable to you in later exercises, where you'll be called upon to use this knowledge to produce specific effects.

4 COLOR VALUES

When you ask the question, "What is the value of a color," you're really asking, "How light or how dark is it?" In other words, you're distinguishing the lightness or darkness of a color from that of other colors. In painting parlance, this is often referred to as *value distinction*. In order to better understand what we mean by this term, it's necessary to explore the tonal values of the black and white scale first—where light and dark are most easily distinguished—before studying the values of colors. First let's see how many grays you can obtain.

EXERCISE 26: VALUE MIXING PRACTICE

We all know that by mixing black and white together we produce a basic gray. But just how *many* grays can we mix? In this exercise, we'll explore the variations of grays that are possible by mixing black and white exclusively.

TOOLS: clean palette
 mixing knife
 three sheets of white 8½" x 11" paper

COLORS: titanium white
 ivory black

First squeeze equal amounts of both black and white paint onto your clean palette. Mix these together thoroughly and you now have a basic middle gray from which you can mix all the others. Take small amounts of this middle gray and by either adding a little black for a darker

value or more white for a lighter value, you should be able to mix at least six more variations of grays. These, along with your basic middle gray, make a total of seven in all, each ranging from an extremely light gray to a very dark low value gray. You'll discover that a little black goes a long way in changing the value, so add only a little at a time as you go after the darker values.

You now have seven graded grays, a black, and a white. Transfer each of these nine colors to your sheets of paper. Apply the paint with your brush in rectangular shapes, size 1″ x 3″. After the paint has dried, cut up the papers into strips, so that you have nine strips of paper, each measuring 1″ x 3″ and each a different value of gray. Save these papers for the next exercise.

EXERCISE 27: A COLLAGE OF VALUES

The purpose of this exercise is to see how different values affect each other when they are placed in various positions on a gray surface. In order for this picture to be successful, it must contain a number of gray areas, rendered in values ranging from black to white with at least seven different grays in between, making a total of nine, just as you did in the previous exercise. Therefore, in this exercise, we'll make three collages, using strips of papers that you've previously painted with these seven grays and black and white in the last exercise.

TOOLS: a series of nine strips of papers, size 1″ x 3″
one sheet of 8″ x 10″ gray paper
one sheet of 8″ x 10″ medium gray paper
one sheet of 8″ x 10″ dark gray paper
one jar of Sobo or Elmer's glue
colored tissue papers or colored gelatins

First, cut the nine gray strips in half so that you have eighteen pieces to work with. Then, place the very dark pieces on the light gray 8″ x 10″ sheet. Juggle the small pieces around until you have a pleasing composition. Glue them down. Next, place the very light pieces on a medium gray paper, and juggle these pieces until you have a good arrangement. Glue them down. Finally, place the medium gray cut-up pieces on the dark gray 8″ x 10″ paper, and juggle the small pieces until you have a pleasing picture, and finish up by gluing these down.

As you study your three collages, try to see the different values as

colors. That is, if you were to superimpose a transparent color over each one of the grays, you would begin to recognize your color with a value.

As a final step, therefore, I suggest you get some pieces of colored transparent gelatin or tissue paper and experiment by placing them over your collages. You'll be able to actually see for yourself what happens to a color when it's blended with one of the grays.

EXERCISE 28: CITYSCAPE IN VALUES OF GRAY

Now you're ready to do a painting using forms which you'll fill in with easily identifiable values of gray. However, before you plunge in, decide whether you wish to produce a minor or high key painting. For a somber minor key—twilight zone mood—use the dark grays and black. On the other hand, if you wish to express a high key mood, use the light grays along with the pure white. If you use all the grays on one canvas, the result will be a complete study of your white and black tonal values. Remember, the object of this exercise is to study the light and the dark of these values.

TOOLS: two palette knives, spatula and trowel-shaped
canvas, 24″ x 30″

COLORS: titanium white
ivory black

It's essential to place each tone so that it can be clearly seen. For this reason, I suggest for your subject matter a composition based on geometrical architectural shapes of the city skylines; in short, a cityscape. Plan your composition in such a way that the forms are broken up into as many architectural sections as possible. You'll now have a marvelous opportunity for painting in these areas, using up all the grays you've just mixed.

With a thin wash made by thinning your black paint with turpentine, sketch in the composition. Then mix the values of gray you'd like to use in your painting, just as you did in Exercise 26. Next, distribute the key dark spots and use pure black applied with the trowel-shaped painting knife. Then put in all the pure white areas, then all the different middle grays, working from light toward dark, until you've used them all. In painting, place each tone next to the other so

that the edges touch. In this way, you'll have little trouble in identifying each different gray and distinguishing it from its neighbor.

EXERCISE 29: GRADED SCALE PAINTING

In the previous exercise you painted definite tonal areas which were clearly placed. In the finished picture, these areas were easy to identify. In this exercise, however, you'll blend the tones together. These gradual blendings, from the extreme light going toward the darks, are what create the illusion of space on the flat, two dimensional surface of your canvas. The best way to render this illusion is to use light and shade and the five basic tone values: light gray, medium gray, medium dark gray, dark gray, very dark gray. Add to this white and black, of course, which will give you a total of seven values in all. The transition from one tone to the next will be gradual. This is called a *graded scale painting*.

TOOLS: flat bladed palette knife
assorted brushes
turpentine

COLORS: titanium white
ivory black

Think of a landscape with large expanses of undulating hills and sweeping planes. The time of day should be sunset, because this will give you the opportunity to arrange interesting graded areas throughout your composition, with the light source emanating from the setting sun.

First use a medium-toned gray for the sky background and cover the entire canvas with it, which we call the ground color. Then, with a clean rag, wipe out the shapes of the individual clouds. You may want to use your knife to do this: either one will do. But scrape off as much of the ground color as you can. You can have as many clouds as you like in your composition; in fact, the more the merrier.

Next, determine your source of light. What time of day are you planning to render, and where are the rays of the sun coming from? When this is established, you're ready to paint.

Start by painting the lightest side of each cloud (determined by which direction the light is coming from), using pure white for this purpose. Then gradually introduce the middle values, using each of

the half-tone gray mixtures you mixed previously. And last, in order to achieve a three dimensional effect with your graded grays, paint in the very dark areas.

The best way to gradually blend the different tonal areas is to take a clean, dry, bristle brush and gently scrub or work the tones together so that the transitions appear gradual. Gently pat the wet areas so that the different grays blend softly into one another, leaving no discernable mark or edge to show where one gray ends and a different one begins. Use a clean brush for each new area to blend.

You've now learned how to create the illusion of volume by gradually shading the different cloud forms. Your painting should be a success if you've used up all the different grays on your palette in sequence, modeling each form so that the extreme darks are in the shadow side and all the different grays are graded toward the light.

EXERCISE 30: JUXTAPOSING LIGHT AND DARK (CHIAROSCURO)

Chiaroscuro is a term in Italian, describing the way you arrange and balance the lights and shadows in your painting. In order to successfully balance your lights and darks, you have to know the value scales. Once you do, you'll be able to create the dramatic, romantic effects which are characteristic of chiaroscuro.

TOOLS: two palette knives
assorted brushes
canvas board, 16" x 20"

COLORS: lamp black
titanium white

For subject matter, think of rock formations in a moonlit landscape. Plan a composition where the forms fill three-quarters of the canvas, leaving one-quarter to show the sky where your dramatic light is coming from. Sketch in large rocks adjacent to small ones. (You might make some sketches of actual rock formations seen in a rockbound coast of a Maine landscape.) Keep track of the source of light; it should be consistent. The opposition of the lights and darks will give interest to your subject. In order to see your subject in terms of the chiaroscuro idea, it's best to see the areas without their color, considering

them instead in terms of a black and white value scale, for only in this way will you be able to understand the term chiaroscuro.

The first step is to block in all the extremely light areas. Follow this by painting in all the extreme darks and blacks; add the grays last of all. Work at first only in the black and white scale, seeing how many gradations of grays you can mix. Beginning with white, and by adding a little black to the white each time, see how often you can change the values as you approach the black.

When you've done this, it's time to superimpose or scrub your colors into the areas you just painted. The result will be similar to the effect created by placing a piece of transparent colored gelatin over the grays.

Now you're finished. If you've distributed your dark and light areas properly, you should have created a very dramatic and romantic mood which is what this method of painting is primarily noted for.

EXERCISE 31: PORTRAIT FROM LIFE IN CHIAROSCURO

The following is an exciting shadow exercise where we will be utilizing what is referred to as "The Rembrandt Lighting"; that is, using the kind of light we see in the work of the great master. This light comes at a 45° angle from above and side, causing the nose to cast a sharp shadow onto the cheek. At the same time, the light from the other side of the face casts a reflected light onto the same cheek, thus forming a triangular patch of light. Try it.

TOOLS: assorted brushes
 clean palette

COLORS: burnt umber
 titanium white
 ivory black

Seat your model in the kind of light described above. Now prepare the palette by mixing your seven grays, to which you have added burnt umber. Then sketch in your subject, making a very accurate rendering of what you see. Paint in all the very dark areas first and then, in sequence, all the other values, until you come to the lights. Last of all, put in all the pure white highlights.

EXERCISE 32: EXCITING SHADOW AREAS

The purpose of this exercise is to do a painting with exaggerated shadow areas. This will not only develop your skill in using your values, but will show you that you can enliven your painting with exciting shadows.

TOOLS: assorted brushes
canvas, 16″ x 20″

COLORS: ivory black
raw umber
ultramarine blue
viridian
titanium white

Do a painting of an imaginary row of people seen in silhouette, standing in front of a backdrop of strong light produced by spotlights. The people will cast long shadows and these shadows should be painted in black. Keep the forms almost black and the background several shades of grays, with light areas breaking through this background color.

The finished picture should be a combination of light and dark areas; either light figures against a dark background, or black figures against a light gray background. In order to get exciting shadow areas, liven up all your blacks. You may find that things will perk up considerably by adding ultramarine blue or viridian green to your black areas. Since the dark of a color juxtaposed with the light is really determined by the source of light, determine this before you start painting in your figures. Then you can plan on where to put the shadows cast by the different figures.

EXERCISE 33: A STILL LIFE IN HALF-TONES

As you know, a half-tone is a middle value or a grayed-down version of a color. When a little black is mixed into a pure color (red, for example), it becomes a subdued version of the red and is referred to as a red half-tone, or a blue half-tone, namely, the half-tone of whatever pure original color the black was added to. Since working in half-tones is vital to your understanding of color values we'll do a painting exclusively in half-tones.

TOOLS: one each of an orange, red apple, green pear, banana, lime,
plum
assorted brushes
white table cloth and chair
canvas, 16″ x 20″

COLORS: ivory black
raw umber
titanium white
cadmium red
cadmium yellow
cobalt blue
cadmium orange
viridian
cobalt violet

Casually drape the white cloth over the back and seat of the chair, then arrange the fruit in an interesting way on the chair seat so that the light is casting definite shadows of the fruit onto the white cloth.

Remember, no matter what your subject is—a landscape, portrait, still life, or room interior—this source of light is one of the major problems to be resolved right off. So get into the habit of being selective when you choose a site for your subject. Whenever possible, choose an area or room that has a north light, because this light lasts longest, is free from changing shadows, and is the one that affords the best opportunity for studying subtle tonal variations of the subject.

Quickly sketch in your composition with a neutral color and paint in the white cloth covering the chair back and seat. Next paint in the fruits. Then carefully work in half-tone versions of each of the different colors. Do this by scrubbing the half-tones into the wet pure paint you've already applied.

Your finished painting should be a softened, poetic rendering of the subject, free from sharp edges or hard shadows. Notice how subdued the colors are, an effect you may desire in later paintings you do.

Vibrating the half-tones

The half-tone mixture in itself is not very lively. This is perfectly all right, since its role is to support the extreme lights and darks in the picture. There may be times, however, when you'll want to pep things

up a bit and, in the next two exercises, we'll explore ways of doing just that.

There are two ways to vibrate your half-tones: (1) To the half-tone, add the complement of your basic half-tone mixture (see Chapter 3). For example, to a red half-tone add a little green; to a blue half-tone add a touch of orange; and to a yellow half-tone add a dab of violet. (2) Another way to vibrate the half-tone is to add to the half-tone a little of whatever the adjacent color on the painted canvas happens to be. And a truly lively half-tone is one where you follow both these procedures.

You'll find that your half-tones have now been transformed into vibrant shaded versions of their original colors. These are the ones you'll be using when you wish to create poetic, atmospheric moods on which to build your other areas. And now to work:

EXERCISE 34: VIBRATE THE HALF-TONES WITH COMPLEMENTARY COLORS

First let's see what happens to the half-tone when you add some of the complementary color to the half-tone mixture.

TOOLS: clean palette
assorted brushes, flats and brights
palette knives
canvas, 20″ x 24″
blue drapery material
green wine bottle
fruit: one red apple, one orange, one banana

COLORS: titanium white
ivory black
lemon yellow
cadmium yellow
cadmium orange
vermilion
cadmium red
alizarin crimson
cobalt blue
Prussian blue
permanent green light
viridian green

green earth

cobalt violet

raw umber

First, place the still life objects on a table, arranging them in an interesting composition with the blue fabric draped over the table so that it falls into soft folds. This will serve as background for your objects. Select a spot in your studio where there is a direct light shooting onto your set-up. Now you'll be able to study the reflection of the colors as they blend into one another. Get a good look at the still life set-up from all angles before selecting the view you'll be painting.

Now mix your colors. Bear in mind the temperatures of the basic colors first before adding the complement (see Chapter 2). Therefore, mix a *warm primary* with its *warm complement,* and a *cool primary* with its *cool complement.* For example, to a warm vermilion add a touch of yellow-green; and to cool alizarin crimson add cool viridian green. To cold lemon yellow add pink violet; to warm cadmium yellow add blue violet. For the blues, cadmium orange will do.

To each of the above, also add a touch of raw umber and a tiny amount of black. To the basic color of each object or color area, add a little of whatever the complement happens to be.

Using a thin wash of a neutral color (gray or yellow ochre), loosely sketch in your composition, indicating where the shadows fall (this will depend on where the source of light is coming from).

Start by mixing the half-tone value of the largest area of your subject. In all probability, this will be the background area made by the blue drapery. Therefore, mix together your blue, a little black, and raw umber, using a medium-sized brush. Paint in the drapery, leaving the white of the canvas showing where you plan to put in the highlights. However, to the parts that are in shadows or the darks of the drapery, blend a dab of its complement—orange—to the half-tone you've just finished applying. Now follow the same procedure with each object. Roughly paint in the half-tone for the green wine bottle, and to its shadow area mix in a drop of red.

To the red apple, add a spot of green on its dark side; on the shadow side of the banana, brush in some violet. To the dark of the orange, blend in a little blue, simultaneously retaining portions of the original white canvas wherever you plan to put in the light areas. To these white areas, paint on the pure mass tone color of each object and finish off the painting by putting in sharp accents, applying the paint with the tip of the palette knife.

This exercise will show you how to render objects so that they'll appear as close to reality—according to classical tradition—as possible. You'll note that adding some of the complementary color to a half-tone is the time-tested way to paint and this method dates as far back as the Italian Renaissance. And you'll notice how lively the half-tones have become!

EXERCISE 35: THE HALF-TONE REFLECTING ITS ADJACENT COLOR

Now let's see what happens to the half-tones when you add some of the adjacent color to the half-tone mixtures.

SUBJECT: orange drapery
 white vase or jug
 assorted fruit

TOOLS AND COLORS: same as preceding exercise

Study your subject from all angles in order to choose the most interesting view. Determine where your source of light is and where the shadow areas fall. Sketching with a thin wash of a neutral color, block in the subject. Forget the details. Suggest the large surfaces in planes and masses.

Using your half-tone mixtures, paint in all the spaces that suggest a middle value, leaving the empty white of the canvas showing where you plan to put in the highlights. To the spaces that are in shadow, blend in a little of whatever color happens to be next to it. And lastly, put in the pure mass tone color on the unpainted portions of the canvas (your highlights). Finally, put in the sharp pure color accents by using the tip of your trowel-shaped painting knife.

The principle of adding an adjacent color to a half-tone results from an accurate observation of Nature: all colored objects produce a chain-reaction, each reflecting a little of the adjacent color.

If you study the canvas you've just completed and compare it with the subject you used as a model, you'll clearly see the similarity. And you'll see that the half-tones are a lively addition to the over-all composition.

EXERCISE 36: WITH THE COMPLEMENTS AND ADJACENT COLORS TOGETHER

Now you're ready to combine both methods of vibrating the half-tones. You'll find that this combination will give you the best results.

SUBJECT: green drapery for background
several wine bottles (green and brown glass)
one peach, two pears, one orange, three plums

TOOLS AND COLORS: same as in preceding exercises

Follow the same procedure for painting the still life as you did in the last two exercises. This time, however, add to all the half-tone areas the complement of the basic color you used in making the half-tone mixture, *plus* a little of whatever the adjacent color to the half-tone happens to be. This combination will give you the most vibrating half-tones of all.

EXERCISE 37: DIFFERENT GRADATIONS IN INDIVIDUAL COLORS

In this exercise, we're going to take a look at values in all colors. In learning the range of values of particular colors, it's important to remember that the darker the color, the greater the range from light to dark. To get the maximum from the work in this exercise, select any solid colored fabric for a subject. I've selected one of the darker colors, green in this case.

As a rule, the half-tones are your starting point mixtures. Since you'll be using a great deal of these half-tones, I suggest you mix generous amounts of them. To get a basic half-tone mixture, combine the mass tone color of the object you're rendering with a little raw umber and ivory black. Do this with your three source colors, red, yellow, and blue. You'll find that these resulting half-tones will prove indispensable as springboard values and that using them is the simplest way to establish an over-all harmony for your canvas. When you're ready to lighten a tone, simply add white to your middle value (half-tone) mixture; to get a darker value, add black. Of course, you can get as many different gradations as you wish simply by varying the amounts of black or white you add to the individual half-tone mixtures. But let's paint it out and see for yourself.

TOOLS: green drapery material
canvas, 20″ x 24″
assorted brushes
clean palette
flat blade palette knife

COLORS: viridian green
cadmium red
raw umber
ivory black
titanium white

In this exercise, distinguish one value from another in order to better learn how many different gradations you can obtain by adding different amounts of either black or white to a color.

First, squeeze out the colors next to one another. Take a generous amount of the basic color of your subject, in this case, green. Your subject is to be a still life of only drapery material of a solid color. Drape the fabric so that it flows in graceful folds over the back of a chair, onto the seat, and then over the edge toward the floor. Place the whole set-up in a path of light from a window. Arrange it so that you get interesting shadow areas throughout. Still lifes are good as subject matter, because you're able to take as much time as you like to observe, at first hand, the actual tonal nuances and variations in front of you, even when dealing with only one color.

Make your half-tone mixture, and mix enough to cover your canvas. Using a thin wash of this half-tone (thin it by adding turpentine to some of it), sketch in your subject. This is a very important step, because the success of everything depends on a good start, so do try to get as interesting, as non-clichéd a composition as possible.

Determine where the middle values are; next the darks, and lastly the highlights. Plan an exciting distribution of all your light and dark areas, and then study your subject to decide where the variations go. And now to paint.

Using a good sized brush and the paint you mixed previously, paint in all the areas that suggest half-tone values. Next add a bit of black to some of the half-tone mixture and paint in all your dark areas. Now add lots of white to the remaining half-tone mixture and paint in all the light areas, since this is the way you'll get the luminous quality that makes the picture glow with life. The last step is putting in the mass tone color and details. Simply add the pure color and scrub it into the wet paint that is already on the canvas. You may either use the palette knife or a clean brush for this. Apply the paint so that the under color blends with the one you've just added.

EXERCISE 38: EXPLORE THE MASS TONE

Now that we have explored the tonal values of the black and white scale and the half-tones, we're ready to venture into the dazzling world of pure color. The mass tone is the color as it looks when first squeezed from the tube: pure and untouched by anything else. As a first step toward understanding what we'll be discussing, it's best that we give these color values identifying titles. At the same time, we'll explore what each is potentially capable of doing.

TOOLS: canvas board, 24″ x 30″

palette knives

assorted brushes

turpentine

rags

COLORS: all the colors you have in your paint box

While this exercise may seem like a "Just for Fun Exercise" because of the festival of colors you'll be using, don't be misled. This is really an essential beginning exercise which will point out how much light a given color is capable of projecting naturally, and how dark a color can be when compared to its companions.

For a subject, I suggest a non-figurative idea, a composition with no realistic image. Place your canvas board flat on a table and brush in the outline of your design with a thinned-down black.

Break up the picture surface into as many small abstract shapes as possible so that you'll have room for trying out each color. Use each one systematically, squeezing a little directly onto the canvas. Spread each color out, using your palette knife; wipe off the excess paint from the knife, repeating the process with the next color. Control the color scheme by the rhythm of your composition. Fill up your canvas with an array of colors until you've used all the ones in your kit, and don't forget your white and black!

After completing this exercise, you'll see what a tremendous impact each pure color has when placed next to another. You'll be able to see how light or how dark each one is simply by studying the painting you've just finished, and you'll note that colors in the *yellow* family have the most light and, with white added, even *more* so; the *reds* are in the middle value scale; the *blues* cast the least light of all.

EXERCISE 39: COLOR VALUES IN A COLLAGE

One of the best ways of seeing color values is by doing a collage. Flat areas of colored paper will clarify value distinction in a way that's more obvious, perhaps, than oil paints.

TOOLS: package of colored construction paper, 10″ x 12″
small jar of Elmer's glue
18″ x 24″ heavy cardboard or canvas board panel
scissors

Think in terms of the basic forms of the circle, the square, and the triangle, and proceed from there for compositional ideas. This will be a collage using torn papers of different sizes. You may either cut or tear the papers by hand, and in all different shapes and sizes. The torn edge is always more interesting because of its softened contour. But you choose the one you like.

Arrange the pieces; move them about on the canvas. Since you're dealing with a variety of tints and shades, you'll be able to see the different values at a glance. The black and white papers will help set off the values of the various other colors. When you've completed a satisfactory composition of the geometric shapes and have arranged them in an interesting pattern, it's time to start pasting the papers onto the panel. Work with care so that you won't lose your design. Start first by pasting the layer of papers in the background area; that is, the one you want directly on the back of the canvas. Follow this with the succeding layers of other papers of the design, saving the topmost layer for the very last.

Now study your collage. Can you distinguish the values within the colors? If so, you've achieved the purpose of this exercise.

EXERCISE 40: COLOR VALUES IN LANDSCAPE

You may find that by relating to a specific subject, you'll be able to see how color values can be used in a painting. While studying values in a definite subject, you'll probably find it easier to retain what you've learned. So plan to work from an actual scene and render it as you see it.

TOOLS AND COLORS: same as in Exercise 38

Try to visualize an autumn landscape with definite areas defining the location of the sky, fields, bushes, trees, and barns. Sketch in your subject matter roughly, because this will lend verve and excitement to your finished painting. Paint the whole surface with a very thin gray (mix ultramarine blue, raw umber, and white to create the gray). With a soft rag, wipe out the outline of the forms in a landscape, so that you are actually drawing with the rag. Now build up the composition by brushing on all your dark colors, then all the light colors.

Now, correct your drawing, using a pencil. This will help you to see your images. Go over this with a medium-sized brush, using raw umber for shadows. Next, put in the reflected lights (light in dark). Paint the light colors generally and make no effort to obtain details; rather, give a broad treatment of the planes and masses you would see in a landscape.

Now that you've completed all the exercises in this chapter, you really should be well equipped to resolve any questions relating to color values. You've learned to distinguish values in the black and white family. You've completed exercises which exploit dramatic shadow areas and learned the meaning of chiaroscuro. The half-tones have shown you the way to creating poetic effects in your painting. And you've seen how to grade individual colors and to distinguish the tonal values of the pure colors. This should all have helped you in painting the landscape.

5 COLOR PERSPECTIVE

In this chapter we will consider the application of color to the problem of perspective. In dealing with two and three dimensional problems, you'll be called upon to create optical illusions with color. The forthcoming exercises should help you resolve and clarify some of the ideas involved in perspective. The term two dimensional refers to the length and width of the flat surface of your painting surface. The third dimension refers to the illusion of space or depth created by the way you use color in your composition. In these exercises, you'll consider problems of local color and atmosphere; understanding which colors recede, which advance, creating the illusion of depth.

Local color and atmosphere

Local color and atmosphere refers to the colors immediately surrounding your subject. The choice of colors, of course, depends on the type of light illuminating your subject. For example, in a portrait, your choice of colors is determined by the weather and the time of day in which the subject is exposed. Therefore, if your model is outdoors, the atmospheric colors would be quite different from the ones you'd use indoors. This is important, in terms of perspective, because setting the subject in an atmosphere is a very significant means of creating depth in your painting. In other words, your painting is *in space,* not simply a flat layer of paint.

Obviously, at the very outset of your painting session, you must determine the time of day and season you wish to depict. If you're painting early morning or late afternoon, outdoors, the light will most likely be sharp and clear, calling for a high-keyed palette of light

greens, blues, reds, and yellows. The forms will cast slanting shadows of themselves and the dark compositional masses will be clearly defined.

Here are a few hints which may guide you when you wish to express certain atmospheric effects. When you wish to paint a rainy day atmosphere, use as base colors, grays, purples, and all the neutralized primary colors. If you're painting a sharp, clear day, use cerulean blue, cadmium red, lemon yellow, ultramarine violet (in the shadows), and permanent green light. In a sunrise or sunset scene, use brilliant pinks, pastel oranges, purple blues, and violet. For room interiors, use yellow ochre, raw umber, combined with the colors of the furnishings.

EXERCISE 41: LANDSCAPE IN A RAINY ATMOSPHERE

First let's do an exercise which will explore the ways to use color when you're painting a rainy atmosphere.

TOOLS: assorted brushes
canvas, 18″ x 24″

COLORS: zinc white
ivory black
raw umber
Prussian blue
lemon yellow

First mix an atmospheric color that will serve as your ground or base value for the subject. Do this by combining white, a little black, ultramarine blue, some raw umber. Mix these colors together thoroughly and paint this over the entire canvas.

Next, using a small brush which you've dipped in the blue, sketch in the features of the landscape, such as the distant hills, road, trees, houses, etc. Next, paint in all your very dark areas, using a mixture of blue and raw umber, and a little black. Then paint all the light areas by working pure white into the wet base color already there. And, as a final step, paint all the details in whatever colors they happen to be, gently blending these into the base color.

Your finished picture should be a very gentle rendering of a landscape on a rainy day. This was accomplished when you painted the entire picture surface with the color that suggested a rainy day atmosphere.

You'll have the same success if you use this method for painting a clear day, a sunset, a room interior. Use the appropriate colors for the entire picture surface.

Creating depth with color

When we look at the unbroken stretch of an avenue or of trees in a landscape, we see depth. The objects seem to recede at various distances from us, so that—even though the objects may be of the same size—the nearest seems larger, and the farthest seems smaller. Of course, this is an optical illusion. Things don't really disappear into space; lines don't really converge at a single point, and objects of the same size don't really diminish in size. Our eyes play tricks on us.

In order to transfer these optical illusions to the flat surface of the canvas, you use various devices to simulate the same effect. For example, when you want objects to seem placed in far distance, you make them smaller in size. Furthermore, you can paint their outlines in vague, indistinct colors. Use the reverse of this method when you want objects to advance: bolder, dramatic, and focused colors. The size, as well as the color of an object will help you achieve the effect of spatial depth in a picture. You'll see what I mean if you place a piece of tissue paper over the area where you wish to show distance. These areas will appear hazy and softer in hue. They seem to recede.

EXERCISE 42: WHICH COLORS RECEDE, WHICH ADVANCE?

Let's do an exercise exploring this idea with color alone.

TOOLS: assorted brushes
canvas, 18″ x 24″

COLORS: yellow ochre
cadmium red
cadmium orange
cadmium yellow
cobalt blue
cobalt violet
viridian
ivory black
titanium white

For this exercise, paint a composition of faces in perspective. Think of people you just met, brief acquaintances, or older friends and plan an over-all pattern-like composition of them. It's a good idea to have one spot in the picture definitely resolved, an area that will be your frame of reference. In other words, paint in one of the faces, so that all the adjacent parts of your composition can take their cue from this one. Plan the spaces for each face in such a way that the ones in the foreground are larger than those in the background. By adjusting the size in this way, you begin to suggest depth or a third dimension.

Select colors that either attract or repel each other. The activity created in this way will add to the feeling of depth. The neutral colors —yellow ochre and all the grays (that is gray-blue, gray-green, gray-violet, gray-red)—will repel the brilliant ones and the brilliant ones—that is, the hot colors, red, yellow, and orange—are the ones that attract the viewer. In order to intensify the feeling of depth in the picture, you can soften the edges of the receding faces to tone them down even more. Don't forget the background area. It's an integral part of the composition. Now put in the details and accent or dramatize the color of the faces in the foreground areas.

When you've completed this exercise, you'll see that the faces painted in the grayed-down or cool colors—even if they are large in size—will tend to recede, while those that have been painted in the pure, bright hues will advance.

EXERCISE 43: A STILL LIFE IN DEPTH

Let's put this to the test by painting a still life. You'll want to paint the receding objects in subdued colors, the advancing objects in more dramatic colors.

TOOLS: assorted brushes
canvas, 24″ x 30″

COLORS: cadmium yellow
cadmium red
cadmium orange
cobalt violet
cobalt blue
cerulean blue
ultramarine blue

viridian green

titanium white

ivory black

Let's paint an imaginary still life, composed of fruits all more or less the same size (apples, oranges, and pears, for example). Paint the fruit any color you like.

Divide the space of the canvas into two sections, making the bottom half larger than the upper portion. The bottom section will indicate the table top on which you have placed the fruit. The upper portion suggests the wall behind the table.

Loosely sketch in the fruit. Position the fruits so that the ones you want to appear close to the viewer are toward the bottom of the canvas. Place the fruit you wish to appear further away higher up on the canvas.

Now decide on the background colors. Select any color you like, but first gray it down by adding a little black and white to it. Your background areas are usually the largest spaces in the canvas, and once you've filled these in with a neutralized color, you'll find it much easier to resolve the colors of the smaller shapes.

Now, finally, paint in the fruit. Paint the fruits closest to the viewer in the pure primaries. Paint the receding fruits in weaker and softer hues of their true color, softening their edges with a little cobalt violet.

The finished canvas should show that you've accomplished a feeling of distance simply by having weakened the areas which you wanted to recede and by dramatizing the shapes in the foreground. Notice the feeling of depth you have created even in a still life close-up.

EXERCISE 44: CREATING DEPTH IN A LANDSCAPE

Now we'll put the same principle to the test in painting a landscape scene.

TOOLS: assorted brushes
canvas, 20″ x 30″

COLORS: cerulean blue
cobalt violet
cobalt blue
viridian green

cadmium red
cadmium yellow
titanium white
ivory black

Sketch in your subject, using a soft cerulean blue. Sketch in the distant hills, trees, and houses, making them rather small. Then sketch in the objects in the foreground area, making them larger and more detailed than the distant images.

Now establish the solidity of your forms by indicating—with basic pure colors—where the darks and lights of each color go. Modulate or soften the outlines of each of the forms in the background areas, according to the color of each, so that each color blends into its adjacent color. You can do this by using a dry, clean brush for each color edge. Abolish the line completely. Use soft brush strokes in the areas that recede, and bolder, more visible strokes in the advancing areas of the foreground.

Use weak, hazy colors for the receding forms and paint the advancing forms in strong, bright colors leaving the outline edges as they are, sharp and clear. Put in the highlights and details last.

You'll see that by having softened and modulated the outlines of the forms you wish to recede and by having left untouched edges of those in the foreground, you've created the desired feeling of depth in your landscape.

EXERCISE 45: A COLLAGE IN DEPTH

Try a collage, using materials of different textures, such as flat, smooth colored papers; fabrics with visible weaves produced with thick threads; gravel, very small pebbles, and dried seeds. The surfaces of these materials will create a feeling of depth which differs from that created by color alone. The materials that are coarser and of a heavier weight will tend to appear closer to the viewer; those that are flat and thinner will seem to recede.

TOOLS:　collage materials of varied textures
heavy paper
paste

First sketch in a landscape on your paper. Divide the space into three sections so that there is space for sky, mountains, and fields in the foreground. Separate your collage materials: the flat paper cut-outs for the sky area, fabrics for the mountain range, and the thickest of your materials (pebbles and seeds) for the foreground area.

You will easily see how the flat areas seem to recede; how the weave of the fabrics you've used for the middle space (the mountain range) seems to be moving toward you, while the heaviness of the seeds placed in the foreground brings this space sharply into focus, creating a tangible feeling of depth.

6 COMPOSING WITH COLOR

How you use color in your painting will greatly affect the composition. What colors you use—and in what relationship—will be largely determined by compositional factors. For this reason, the spatial relationships of colors are extremely important, and we will study this closely in this chapter. We will explore such problems as the relationships between different areas of color; how colors of different size areas affect each other; how colors change, depending on what other colors are adjacent; poetic effects you can achieve by using flat colored abstract shapes next to each other. We will also consider positive and negative space, the weight and visual balance of colors, achieving different harmonies, dynamic contrasts, or discords in your composition. With this knowledge, we can then consider ways of achieving movement and rhythm in your painting with the proper use of color.

Colored torn or cut-up papers are indispensable for carrying out many of the exercises in this chapter, because they clarify the ideas contained in the problems. Therefore, in the first exercises, we'll use the collage technique.

By considering each color according to its dominant area and under the influence of the one you place it next to, you'll be able to easily select the relationships that are pleasing and harmonious. Try for as many different effects as possible. Juggle the different colored papers around to see which color you think antagonizes, calms, is passive, or at variance with its adjacent color area. Decide for yourself, because this is a highly personal thing; no two people really react the same and your way is always the best, as you'll readily see when you've completed your picture. Every artist expresses his own original feelings and goes about achieving the end results in diverse ways.

The best way to see how different colors relate to one another is to first see them according to the size and shape of each piece individually. In order to study each problem separately, it's a good idea to do three collages in sequence, which will constitute our next three exercises.

EXERCISE 46: RELATIONSHIP BETWEEN AREAS OF SAME COLOR BUT DIFFERENT SIZE

First let's try an exercise using the same color family. You'll see that the size of the areas has a strong effect on the composition of your work, even though the colors may be similar.

TOOLS: small jar of Elmer's glue
16″ x 20″ panel (or any hard cardboard)
sheets of paper of same color family

Cut out or tear pieces of papers of different tones of the same color (such as a variation of reds). Cut some of equal sizes, some quite small, and some very large. Arrange them on a surface that you have painted black—a color I suggest because black both intensifies and better defines any pure color placed over it. For these exercises, think only in pure abstract shapes—not representational—so that you can concentrate on the essentials without being distracted by recognizable forms.

Shift the pieces around on the black background until you reach an over-all pattern that pleases you. First use shapes that balance each other by selecting pieces of the same size. Then try a very large shape next to a cluster of very small ones bunched together. You can also establish a feeling of balance by placing a *large dark* red opposite a very *bright small* red. Try several rearrangements of your pieces of colored shapes. Don't be satisfied with the first pleasant combination. Remember, the purpose of doing a collage rather than a painting is to give you the priviledge of changing your mind so that you can try out many different combinations before you reach for the glue pot. When you have a satisfactory composition, paste down the pieces.

Starting at the top, carefully apply a little glue to both your panel and to the back of the piece of colored paper and press them together. Proceed in this manner until you've finished. You should now see how to get an interesting balanced and harmonious composition by the way you have juxtaposed the varied colored areas with one another. In short, you've begun to learn to compose with color.

You'll know that your composition is successful if all the shapes balance one another. There should also be one shape that is the focal point of the composition around which all the other shapes play a supporting role. This focal point doesn't necessarily have to be in the center of the picture to be chief attention-getter. It can be on the side, with smaller shapes placed so that they balance it.

EXERCISE 47: COLORS OF DIFFERENT FAMILIES

Now let's do an exercise using different colors; so that we can observe what affect color has on shape.

TOOLS: small jar of glue
sheets of varied colored papers
16″ x 20″ panel

Try a small spot of yellow next to a small spot of vermilion. Which is more positive? If you've observed correctly, you'll see that the vermilion is the stronger and more dynamic, eye-catching one. Because it reflects more light, the small yellow will *look* larger when next to vermilion of the same size.

Try combining contrary elements next to one another; for example, place a small orange next to a large purple. The orange looks bigger even though it's smaller in size. Try a large blue next to a small yellow and notice that the blue—even though it is larger—*looks* smaller than it actually is. A small bright pink next to a large green makes the pink seem larger. Try a small, luminous yellow shade against a large yellow of a more somber cast—such as yellow ochre—and you'll note that the small yellow looks bigger. You can try all sorts of contrary juxtapositions—such as an extreme light or an extreme dark—so try them all and come to your own conclusions. When you've composed a satisfactory composition, it's time for the glue pot. Do so at once, before you misplace the bits of papers.

EXERCISE 48: ADJACENT COLORS

In this exercise we'll observe what effect a color has upon its adjacent color.

TOOLS: sheets of varied colored papers
panel, 18″ x 24″
small jar of Elmer's glue

You'll be using all the colored papers in this exercise, so you'll want lots of space to move around in. Plan on working on a larger panel, say 18″ x 24″. For a subject, do a bouquet of many colored flowers. Start off by cutting up the papers into mosaic-like fragments to use for

the different flowers—then cut up ample amounts of colored papers to cover each of the areas of your picture. Use all the colors.

Cut or tear pieces of papers of the same color—first in equal sizes, then smaller and larger—and arrange them on a black ground. Try a small spot of yellow next to a small spot of vermilion and see which becomes more positive. In this case, you'll discover that the vermilion, being the stronger and more dynamic, will hold forth more than the yellow. The small yellow, however, will look larger with a small vermilion, because it reflects more light. Since they reflect the least light, the blues will have a tendency to play secondary roles to the other colors.

By playing around with these separate pieces of colored papers, you'll see how they relate to one another in pleasing arrangements. Consider each according to its dominant area under the influence of the one you place it next to. The relationships need not all be pleasing, but they should harmonize. Can you draw conclusions about how a color affects its adjacent color?

EXERCISE 49: COLOR AFFECTS SHAPE

By working in collage, you were able to see that colors have a certain spatial relationship to each other. In this exercise, we'll move on to paints, in order to study exactly the relationship of color to shape.

TOOLS: canvas, 20″ x 24″
assorted brushes

COLORS: cadmium yellow
cobalt blue
cadmium red
permanent green light
ivory black

Since yellow has a tendency to reflect more light than the other colors, yellow shapes seem larger than the same shapes of another color. Yellow gives the illusion of enlarging itself. For this reason, I refer to yellow as the *expanding* color. Place a dab of yellow next to a spot of blue and you'll readily see what I mean. When blue is by itself, it's a receding color; it calms and, at the same time, remains still. But when next to yellow or any other hot color, blue seems to reduce itself, but its hue becomes more brilliant at the same time.

Red is a staccato color; it excites and pulsates with life, hopping all over the canvas. However, when a spot of green is alongside red, it quiets down immediately, not much, but enough to warrant attention.

In order to really see how these different colors affect one another, I suggest you do the following exercise. You'll see that when you paint a *small* yellow area next to a *large* blue one, the small space will support, or balance, the large one. You'll see that a small black spot will support or balance a *large* red. A small red spot will balance a *large* yellow. A large blue area next to a small yellow will look smaller, a *large* blue will support a *small* red.

EXERCISE 50: LIGHTS AND DARKS AFFECT SHAPE

Let's do another exercise showing how sizes change depending on what color they're painted, this time concentrating on the way *values* affect their shape.

TOOLS: assorted brushes
canvas board, 16″ x 20″

COLORS: titanium white
viridian green
ultramarine blue
lemon yellow
cadmium red
ivory black

Plan a composition based on one form, say a circle. Sketch an over-all pattern of this shape, placing one in a key spot of the canvas. Scale it up, reduce it. In short, fill up the canvas with different size circles. Loosely paint all the larger shapes in white (white with a little color added, if you prefer). And use very dark colors for the small shapes. When you've finished, you'll notice that the big shapes appear even larger when painted with a light color and the smaller areas look much smaller painted in the darker color. You'll find that you can either enlarge or diminish the sizes of the circles by the distribution of the light and dark colors.

EXERCISE 51: COLOR SHAPES IN A STILL LIFE

Let's put to use the observations we made in the last exercise. Let's paint a still life and see how color affects shape.

TOOLS: canvas, 20″ x 24″
assorted brushes

COLORS: cadmium yellow
cadmium red
cobalt blue
violet
permanent green light
cadmium orange
ivory black

The first step is to plan an interesting composition. You'll be able to handle the exercise more effectively if you have a variety of shapes to work with. Think of triangular pears, crescent shaped bananas, moon-shaped oranges, rectangular bunches of grapes, circular bowls, and so on. Draw an imaginary still life. You don't have to be true to life in this exercise, because your drawing will identify the shapes of each object, leaving you free to select your colors according to how you wish the color to affect their shapes.

Next, plan your color scheme. Apply the colors in stark primaries, in flat poster-like brush strokes, bringing each color to meet its adjoining one. If you wish the banana to recede, you can paint it blue; if you want the orange to look bigger, paint it yellow and the watermelon violet, just to see how it changes next to the others. And don't forget black and white! Do you see how color can work for you in composing a representational painting?

EXERCISE 52: POETIC EFFECTS WITH COLOR

Transform a canvas covered with a patchwork of raw colors into a field of subtle landscape forms. You'll find that the energies inherent in each color will be greatly enhanced when they are enclosed in concise, individual shapes and placed in a pleasing arrangement.

TOOLS: assorted brushes
canvas board, 18″ x 24″

COLORS: cadmium red light
viridian green
cobalt blue

cadmium orange
cadmium yellow
violet
titanium white
ivory black

First sketch in the outlines of the individual areas within the landscape, areas such as sky, clouds, hills, fields, road, lake, houses, or figures. Keep these areas large and uncluttered so that the colors relate to one another without the added distraction of small details. Remember, the way you put your forms together will determine the ultimate unity of your composition. So give this first step careful attention!

Next, plan your color scheme so that each color complements the one it's next to, using each in its pure state right out of the tube. For example, place a red next to a green, blue next to an orange, or yellow next to violet. Finally, while the colors are still wet on the canvas, take a clean, dry brush, and gently work the edges of each of the areas so that they are blended together. In this way, you'll find that the raw colors now have atmospheric, delicate variations of their parent colors, transforming the whole from a flat poster into a subtle landscape.

Positive and negative space

When they look at a painting, artists often speak of positive and negative space. In the layman's terms, positive space is likely to be the "subject"—a figure standing in front of the sky, let's say—while the negative space would seem to be the "background"—the sky around the figure and patches of sky that appear under his arms, between his legs, etc.

However, there's an ambiguity in the terms positive and negative space, since the two go together. You cannot possibly see positive space unless there is also a negative space, for the two are permanently linked to one another. You'll discover this the moment you begin the coming exercises. The best way to clarify these terms is to take each area separately. We'll take positive space first.

EXERCISE 53: PORTRAIT: TONING DOWN THE POSITIVE SPACE

Positive space, most frequently, is the space in your composition making the *statement;* for example, the face in the portrait, the house in the landscape, or the largest form in your abstraction. Let's try to demonstrate this by using a portrait for subject material.

TOOLS: assorted brushes
canvas, 20″ x 24″

COLORS: cobalt blue
cadmium yellow
Naples yellow
violet
alizarin crimson
titanium white
ivory black

Although the face is the most prominent positive area in a portrait, the painting will have a greater impact if you tone *down* that area, rather than accentuate it. Start out with a strong structural sketch of the subject, carefully planning the different spatial areas of both subject and background, and keeping the background bare. Plan the color scheme so that the key color is on the face, and apply the paint with broad, loose brush strokes.

Finally, depending on what mood you're rendering, modify the colors of the face by blending them with the colors in the background. This is achieved by working the shadow side of the face gently into the background, and vice versa. By using the negative color into your positive space, you'll create the illusion that both spaces are floating in the same atmosphere, because the face has been subdued and no longer looks as if it had been superimposed onto the background.

EXERCISE 54: CHEERING UP THE NEGATIVE SPACE

The negative space is the area in your picture that is *not* making a statement, usually the background area in the portrait, or the spaces around the house in the landscape, or the drapery behind the apples in the still life. The negative spaces are important because they create the atmospheric mood or they give support to the main subject or theme of the picture. In this exercise, dealing with negative space, we'll again use a portrait study for subject matter, concentrating this time on the background area.

TOOLS: assorted brushes
canvas, 20″ x 24″

COLORS: titanium white
cobalt blue
viridian green
lemon yellow
cobalt violet
yellow ochre
raw umber
alizarin crimson

Don't do too much to the background. Everything you do to this negative area must be done with a "light touch" or else you run the risk of the negative space turning into a positive space! Remember that its functions is to support the main subject and to create the desired mood. On the other hand, don't underestimate its function, because this area plays an important role in determining the success or failure of your finished painting.

There's always the other danger that the negative space will dissolve onto a dead space area in your canvas. In this exercise, we're going to see how we can cheer it up a bit.

First sketch in your portrait, blocking in the areas of both subject and background. Next, indicate where the subject is—out of doors in a landscape, or in a room interior—and lightly sketch these in. Next, plan your color scheme. Keep the colors in the background subdued so that they won't compete with the subject.

Finally, applying the colors with thick, visible brush strokes, work in some of the foreground colors into the background. Select only the highlight colors for this purpose. In this way, you'll have accomplished your goal of cheering up the negative. To be more specific, the dabs of bright color from the face that you've placed onto the neutral background color now make the negative area more animated, without destroying any of its character.

EXERCISE 55: COMBINING NEGATIVE AND POSITIVE SPACES

Now, in this exercise, let's see what happens when you combine what you've learned in the last two exercises by doing a collage.

TOOLS: colored papers
canvas board, 16″ x 20″
small jar of Elmer's glue

Select two papers of different colors, preferably one cold color and one warm color; for example, red with blue, yellow and violet, or yellow with green. For the purpose of this exercise, we'll use violet and yellow. First take your sheet of yellow paper and sketch two horizontal, wavy lines on it. Sketch one about a third of the way down from the top edge and the other about a third up from the bottom edge, thus breaking the space up into three sections.

Place this paper on a cutting board and cut the sketched lines with a single-edged razor blade. Place the blade over the lines you have drawn and cut through each line; then carefully pull the paper apart, placing it on top of the violet paper. The opening created in the yellow sheet when you separate the cut will now become what is called negative (space revealing the violet paper underneath). The positive space is the superimposed yellow shape.

You'll find that the negative violet space, created in this manner, will *echo* the shape of the superimposed yellow shape and will create an illusion of unusual depth. After you've composed a suitable design, glue down the yellow sheet onto the violet. Starting at the top, carefully apply a little glue to both the panel and the reverse side of the colored paper and press the two together. Proceed on down your picture.

After completing this exercise, you'll be able to identify the negative and positive areas quite clearly. It's always best to work in the abstract idiom, so that you can concentrate on the problem without the added responsibility of rendering pictorial images.

EXERCISE 56: JUXTAPOSING LINEAR AND AMORPHIC SHAPES

As a final exercise in composition, do a painting which combines different kinds of shapes, using what you've learned about putting color to use.

TOOLS: assorted brushes
canvas board, 20″ x 24″

COLORS: cadmium red
cadmium yellow
cobalt blue
ivory black
titanium white

Painting a "people picture" will provide excellent opportunities to juxtapose both linear and amorphic shapes. The obvious amorphic shapes will be the figures, and the linear will be background areas, especially if you choose a room interior. See how inventive you can be in planning your composition. Working from memory, think of the faces or figures of different people and lightly sketch these onto the clean canvas. Then plan the color scheme, using a different color for each figure. Use pure, definite colors at first.

The next step, depending on the color of the background, is to softly blend a little of this background color into the shadow side of each figure. Plan your spaces so that you use silhouettes of the different forms, avoiding any attempt at literal reality. Rather, suggest your figures by their outlines, breaking these up only when you want to suggest the shadow side of each form.

You'll discover that the interrelationship of the colors in your negative and positive spaces will create a unity and harmony very pleasing to the eye.

Weight and visual balance

Every color suggests a sensation of weight in a given situation. As a rule, the space around your color spots also has a shape. Therefore, the size of the surrounding space will determine how much weight the color form has. (See the painting by Alexander Calder.) Although this may sound very abstract, I'm sure you'll see for yourself in this exercise exactly what is implied.

In the forthcoming exercises, we'll explore the sensations of weight that certain colors arouse and, since no two people react in exactly the same way, we have to try to find a common frame of reference to guide us. Most artists agree that the best way to feel the weight of color is to think in terms of visual balance. The way colors balance each other depends on *where* on your canvas colors are placed. The following exercise will explore this idea. From there, you'll do a more complicated exercise in which you'll observe how brilliant, intense colors will balance each other when placed next to areas of a whitish value.

EXERCISE 57: BALANCING THE SAME SIZE AND COLOR

The purpose of this exercise is to study how an object of the same size and color will look when compared to others of similar size and color. But let your own eye be the judge.

TOOLS: assorted brushes
three sheets of 18″ x 24″ heavy drawing paper

COLORS: cadmium red
cadmium yellow
cobalt blue
titanium white

For a subject, select one still life object, perhaps an apple, a bowl of fruit, or a teapot.

First take the three sheets of paper. On the upper portion of each sheet lightly draw a contour sketch of the subject you've selected. (For the sake of clarity, lets say you sketch an apple.) On the lower half of each paper, draw the same apple in exactly the same way as you've done above it. Repeat this drawing on the remaining two sheets, so that you have six drawings of the same subject on the three sheets of paper. This is the best way to evaluate the problem of weights and balances.

Paint the object, using red for one sheet, yellow on the second, and blue on the third. Then pin the three sheets on a wall, so that they can be viewed from a distance.

You'll see that even though the two objects on each page are actually the same size and the same color, the one on the upper portion of each sheet of paper will have greater visual weight than the one on the lower half. How then can you balance the two so that they are equal in weight? By making the color on the upper portion of your painting a slightly lighter hue than the one on the lower half. Try it.

While the paint is still wet, lighten the color by working a little white paint into the object on the upper part of your picture. You'll immediately see the weights shift from the upper to the lower form, thus creating a better feeling of balance.

EXERCISE 58: BALANCING BRILLIANT COLORS

This exercise involves the use of all your brilliant colors in a tri-dimensional view of a still life.

TOOLS: assorted brushes
canvas, 20″ x 40″

COLORS: cadmium red
cadmium orange

cadmium yellow
viridian green
cobalt violet
cobalt blue
titanium white
ivory black

Create an imaginary still life subject, composed of an assortment of different fruits, each of a different color—one red, orange, yellow, green, violet, and blue, with a tall, dark green wine bottle and a large light blue plate standing upright behind the small objects. Imagine how this set-up would look if it were placed in front of a three-way mirror, so that you'd be getting three different views of the subject simultaneously. The effect would be like seeing your subject through a prism. To achieve this effect, first divide the canvas into three sections. Then, in the center section, sketch the still life set-up. In the remaining two sections—the left side of the center and the right side of the center area—sketch in the still life again, as if you were seeing it reflected in a mirror, so that the position of the objects is reversed.

When you've completed your sketch, note that the composition is unbalanced, overheavy on the side where the small items—which are side by side—form a large space in the canvas. (See the line drawing below.) You can correct this imbalance by painting the space behind the small forms in a color of a whitish cast. You'll find that by accenting the open feeling of this space with the whitish color (that is, a color

mixed with white), you'll counterbalance the feeling of vertical weight created by the three wine bottles. The over-all effect will be to balance the distribution of the different colors within the painting with the white open area acting as a link connecting the three separate units.

Since most light colors are attention-getters, you solved the problem of vacant space in your composition by painting it in a whitish color, making an otherwise dead space more interesting.

Different harmonies

Now that we've seen how color can affect balance, let's explore the question of harmonies. Some colors harmonize when used in spaces of a certain size, yet will not harmonize when used elsewhere. Then again, some colors which appear to work well in some combinations may antagonize each other when used in other combinations. In the final analysis, the problem rests with you. No one can tell you how to obtain these harmonies, but with experience you'll be able to recognize this for yourself, provided you observe some basic rules.

We will do two exercises which will help you see how colors harmonize. The first uses colors that harmonize well; the second uses colors which antagonize each other, even though they are placed in the same arrangement as in the first exercise.

EXERCISE 59: HARMONIZING COLORS

Analogous colors will harmonize and blend pleasantly into one another, because they are related by being of the same family source. For example, colors that have blues in their mixture—blue-green, blue-violet, for example—are analogous. Likewise, colors that all contain yellow—such as yellow ochre, orange, yellow-green—are analogous. Because of this close relationship, you'll find that working in analogous colors presents no conflict.

TOOLS: assorted brushes
canvas, 18″ x 24″

COLORS: BLUES	YELLOWS	REDS
permanent green light	cadmium yellow	cadmium red
cobalt blue	permanent green light	alizarin crimson
viridian green	cadmium orange	cobalt violet light
cobalt violet deep	yellow ochre	cadmium orange
	raw umber	

Try painting a landscape which depicts a definite time of day or season. Select the colors that suggest this time and light. For example, you can paint early morning by the sea, a subject in which you can work in the family of blues and greens with white.

First, briefly sketch in your subject with a light blue color, then block in your big color areas—usually the sky, sea, and land—in large brush strokes. Use your lightest blues here. Next, paint in the smaller areas of subject matter, such as the houses, docks, or boats, using the darker blues. Then, with a small detail brush, add any minute accents that might be necessary with either white or extreme darks or black.

Your finished painting will contain pleasant harmonies and a calm mood. If the painting is done all in the family of one specific color, the resulting mood is always peaceful, even if you use the normally vibrant reds and yellows.

EXERCISE 60: ANTAGONIZING COLORS

I know you must be thinking "who wants to paint discords, or an unpleasant mood anyway?" But just for the sake of enlightenment, or in case you should want to someday, if only to let off steam or to get rid of an ugly mood, you should have this experience behind you.

TOOLS: assorted brushes
canvas, 18″ x 24″

COLORS: complementary colors:
cadmium red and its complement viridian green
cadmium yellow and its complement cobalt violet
cobalt blue and its complement cadmium orange

In painting discords, use the colors that are opposite each other on the color wheel (see page 40). The complementaries are typical. As you know (see the chapter on complementaries), complementary colors, when mixed together, give dull, muddy versions of their original components, and lose all their personality.

To paint an inharmonious picture, superimpose one color over its complementary. Try it and see. Do a landscape similar to the one you did in the last exercise (early morning by the sea) and compare the two paintings.

Briefly sketch in your subject with blue, then block in the large areas

with primary colors; for example, set in a blue sea, yellow land, and red sky. While the paint is still wet, scrub some orange paint into the blue, some purple into the yellow, and some green into the red. The result will speak for itself!

EXERCISE 61: DISCORDS IN SHAPES OF EQUAL SIZE

You've seen that discord is created by painting a picture containing mixed complementary colors. However, the shapes which occupy the painting may also create discords, depending on how the colors are arranged. You can't isolate color from shape, because the two make a composition. You can't have one without the other. Most of these exercises in color rely on shapes and masses as their structural foundation.

The nebulous feeling of discord that certain colors project will be the subject of the next three exercises. When you use colors that compete or clash with each other, you create an unrestful, nervous effect. For example, when two strong complementaries are placed in shapes of equal size, the result is usually chormatic discord. Let's try it.

TOOLS: assorted brushes
three 9″ x 12″ canvas boards

COLORS: lemon yellow
cobalt violet light
cadmium red
cerulean blue
cadmium orange

On each of the three panels, sketch in two separate shapes of equal size. Compose the spaces so that the different shapes don't get in each other's way or encroach on each other's room. Divide the panels either lengthwise, in half, or make the shapes go horizontally or vertically. The edges may be either rigid or wavy, whichever way suits you best.

On the first panel, paint one space lemon yellow and the other a bright violet. On the second panel, paint one shape bright red and the other a yellow-green. On the third panel, paint one shape cerulean blue and the other bright orange. By doing this, you'll see how unpleasant certain color combinations can be. You'll see how a feeling of discord is created when areas of equal size are painted in colors which are in opposition to one another.

EXERCISE 62: DISCORDS IN VARIOUS SHAPES

Since we know that color shouldn't be isolated from shape when we wish to express an emotional sensation, let's start off by creating *forms* that disagree with one another, or discordant shapes.

TOOLS: canvas, 24″ x 30″
assorted brushes

COLORS: permanent green light
cadmium red
cerulean blue
cadmium orange
cobalt violet light
lemon yellow

Sketch one very large shape next to a very small one or one angular shape juxtaposed to a softly rounded one. Compose a picture made up of flat planes of discordant shapes. A good subject to visualize is a group of buildings at right angles to each other, showing flat views and angles of each. I suggest barns and sheds with no windows. Plan the color scheme so that you can paint each flat plane in color used raw, at its fullest intensity right out of the tube. Use discordant combinations.

Working in flat applications, place a bright green directly next to a bright red; a clear blue next to a muddy orange; a magenta next to a lemon yellow. Repeat this all over the canvas until you've filled in all the forms. Your finished painting should be very unpleasant!

EXERCISE 63: ABSTRACT DYNAMIC CONTRASTS

Now, using abstract forms, let's paint a picture in which the shapes are moving in contrasting directions.

TOOLS: assorted brushes
canvas, 18″ x 24″

COLORS: assorted opposing colors:
cadmium red
viridian green
cobalt blue

cadmium orange
cadmium yellow
cobalt violet
titanium white
ivory black

Try a composition using bands of different colors placed in counter-point actions; that is, placed in areas of opposing directions. Sketch in three parallel long shapes running along one side of the canvas, going toward the right. Then sketch in five more going in the opposite direction. The parallel lines can be either curved or rigid.

Sketch in your basic composition, using this idea as a guide. Select colors that oppose each other, such as extreme darks with lights. Apply the paint, using visible brush strokes, so that the strokes follow the action of each shape, a means of enhancing the movement of the forms. Since the forms are going in opposite directions, this added activity will greatly enhance the nervous mood of the composition.

You'll discover that colors can be very energetic. When spread out over the canvas, colors can create dynamic tensions which both attract and repel each other.

EXERCISE 64: DYNAMIC CONTRASTS IN A LANDSCAPE

Just as we saw that dynamic contrasts are best expressed in abstract shapes moving in different directions, in this exercise we'll also use oblique angles or lines in a landscape composition.

TOOLS: assorted brushes
canvas, 24″ x 30″

COLORS: titanium white
ivory black
viridian green
permanent green light

I suggest you consider a landscape where you can utilize the verticle action of upright trees in a strong wind. You'll see that the degrees of opposition created by different angles will create the desired dynamic contrasts. Suggest the wind by drawing the trees at an un-supported, off-balance angle. Then, as a contrast, create a counter-

diagonal action of running figures going in an opposite direction, against the wind. These figures will not only offer a contrast by the diagonal action thus created, but will also restore balance to the composition.

Select colors that will suggest an approaching storm: gray sky, dark green trees, clear green foreground, and black for the figures. These colors will contrast sharply with one another and will accentuate the ominous mood of the composition.

Movement and rhythm

Movement, from the painter's point of view, is a combination of rhythmic patterns on the surface of the canvas that creates the sensation of activity in the composition. As a rule, the areas that express the rhythm are the spaces in between the forms of the composition. You'll find that these nebulous in-between spaces begin to take on size and shape when they are considered objectively, independently of the positive space in the painting.

EXERCISE 65: FREE FORM MOVEMENT

In this exercise, we'll see how you can obtain movement with large masses of color.

TOOLS: assorted brushes
 canvas, 24″ x 36″

COLORS: titanium white
 cadmium red
 cadmium orange
 cadmium yellow
 cobalt violet
 viridian green
 ivory black

Start by covering your canvas with four or five areas in different colors. Paint these masses in free form, with no defined edges. It might be a good idea to plan how you're going to break up the picture surface by first sketching in your forms lightly in charcoal. Each mass should relate to the others in terms of its size; that is, all the small shapes together and all the large ones together. Create the dominating move-

ment by placing the leading shapes next to one another and by painting the leading shapes each of a different color. Then repeat the same colors in sequence throughout the composition.

Develop your composition with the idea that your color scheme is comparable to a chain; every color area is a link that relates to the next color so that altogether they make for the total design. The ultimate unity of your composition depends on this chain reaction. To create this related movement, first sketch lightly the individual shapes on your canvas, breaking up the empty space with these shapes. Combine or connect them with colors, then create an interplay, light with lights and dark with darks. This interplay wil create a mood that suggests a lyrical world of natural forms. The repetition of the colors you've used in the leading shapes will create the illusion of moving forms in the painting.

EXERCISE 66: LINEAR AND AMORPHIC SHAPES AFFECT MOVEMENT

You can create the feeling of movement in your composition by combining linear and amorphic shapes. Let's try composing a picture with this in mind.

TOOLS: canvas, 22″ x 30″
assorted brushes

COLORS: titanium white
ivory black
yellow ochre
raw umber
cadmium red
viridian green
permanent green light
ultramarine blue
cadmium yellow
cobalt violet

For this exercise, the nude is an ideal subject. Have your model take a reclining pose, since the desired movement will be determined by the flowing lines of the figure. The linear forms create the *movement;* that is, the hair, neck, arms, thighs, and legs. The forms that *arrest* this action are the amorphic shapes, such as the head, torso, and the floating

forms within the torso, the breasts, abdomen, and buttocks.

As a first step, therefore, it's essential that you indicate the amorphic shapes in the composition. These are the action-stopping spots and, if you want to contain the action within the canvas area, they must be your first consideration. This is the only way you can be sure not to lose the linear forms out of the edges of your canvas. Carefully sketch in these amorphic forms, the head, torso, breasts, abdomen, and buttocks. Since these shapes arrest the action, you should choose colors that are neutral. Remember, you can neutralize any of your colors simply by mixing a little black into a color, or simply by using your earth colors—such as yellow ochre or a whitish raw umber—for a neutral effect. There's no such thing as a flesh tone, because the color of the figure or person depends mainly on what light or atmosphere is surrounding the figure. Remember, you can be as imaginative as you like in the color, because the realism is always carried out in the drawing.

After you have laid in the amorphic areas, paint in the linear areas, the hair, neck, arms, hands, legs, and feet. You'll discover that if you use colors of the same family—all yellows, or all pinks, or all blues—you will greatly activate the movement. From this exercise, you should see that in order to create movement, you should paint the linear forms in the same family of colors, whereas you can be free as the wind in selecting the colors of the amorphic shapes.

Since the amorphic shapes are the torso, breasts, and abdomen, they are more or less stationary, and the color will not prevent them from being the action-stoppers that they are. Again, you can be as imaginative as you like in your choice of color, because the realism will be conveyed by the drawing itself.

EXERCISE 67: MOVEMENT WITH OVERLAPPING PLANES IN SIMILAR VALUES

To create movement in another way, try painting a series of overlapping planes of color in the same value scale. These will create a rolling, even-flowing movement. When the subject is a figure poised in action, perhaps engaged in a sport, such as skiing or dance, the background colors can be used in this way to enhance the movement.

TOOLS: canvas, 20″ x 30″
assorted brushes

COLORS: alizarin crimson
cadmium red
viridian green
cerulean blue
cobalt blue
cobalt violet
titanium white
ivory black

In this exercise, we'll paint running or dancing figures in a ballroom or on a stage. You may want to work in *dark* values of red, green, and blue-grays, with white light accents only on the figures. If you'd prefer to paint an outdoor subject, such as skiing, you'd work in a *light* value color scheme, using light blues, greens, or violets, with a bright vermilion for the accent.

I suggest you select a palette consisting of just two colors. You might use a warm color with a cool one (red with blue, for example). Next, sketch in your subject, breaking up the space into flat color areas; then overlap the planes of color. This can be done by blending the edges into one another with a dry brush, moving in the direction of the action of your subject. Keep the colors in the same value scale. Your colors will create movement as long as they are of the same value. Colors of the same family always create movement because their action is not interrupted by any surprise color interferences.

7 PAINTING TECHNIQUES AND COLOR

The way in which you use your materials has a strong effect on the color qualities you achieve. Therefore, it's necessary to have at your disposal as many techniques as possible to solve the varied problems you encounter. As each subject presents its own special problem, your ability to reach solutions will depend on selecting the technique best suited to it. You should know at once which materials to use while you're in the throes of painting, without having to interrupt the flow of your creative energies to hunt for tools.

Here's what we'll explore in this chapter: how glazing affects color; how scumbling affects color; mixing with your eye; juxtaposing strokes; textural effects and color. When you've mastered these techniques, you can use them one at a time or in combination, in any appropriate situation, without having to think about it. You'll be free to use these techniques when you like, where you like, and how you like. And you'll get the maximum out of your colors.

How glazing affects color

The technique of glazing is old, dating back to the Renaissance. Glazing is a series of superimposed transparent layers of colors, applied one on top of the other, only after the undercoat is completely dry. Each additional color must be thinned sufficiently so that the layer underneath

Vincent Van Gogh: *The Man is at Sea* (right). Oil, 26″ x 20″. Note how Van Gogh's impasto brush strokes accentuate the action of the figure holding the child and the movement of the room interior. The spiraling flames in the fireplace are alive with movement, as is the flowing drapery of the woman's dress. He has added another dimension to the flat canvas surface with the visible action of the brush strokes, combined with a vibrant color scheme. Private collection, Philadelphia. Courtesy, Acquavella Galleries, Inc., New York.

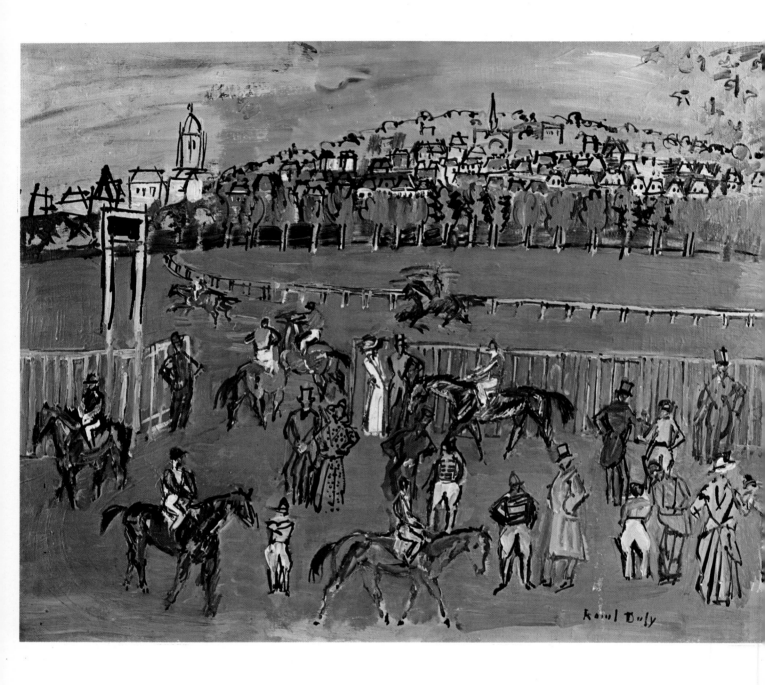

Raoul Dufy: *Les Courses à Deauville.* Oil, 25¾" x 32". This painting is done entirely with analogous colors; all the hues come from the same family. The major areas are yellow-green and warm blues, with superimposed darker blues and yellows in the details of the people and horses. The small spots of red accentuate the harmony of the entire canvas, making for a very pleasant and warm rendering of the subject. Courtesy, Acquavella Galleries, Inc., New York.

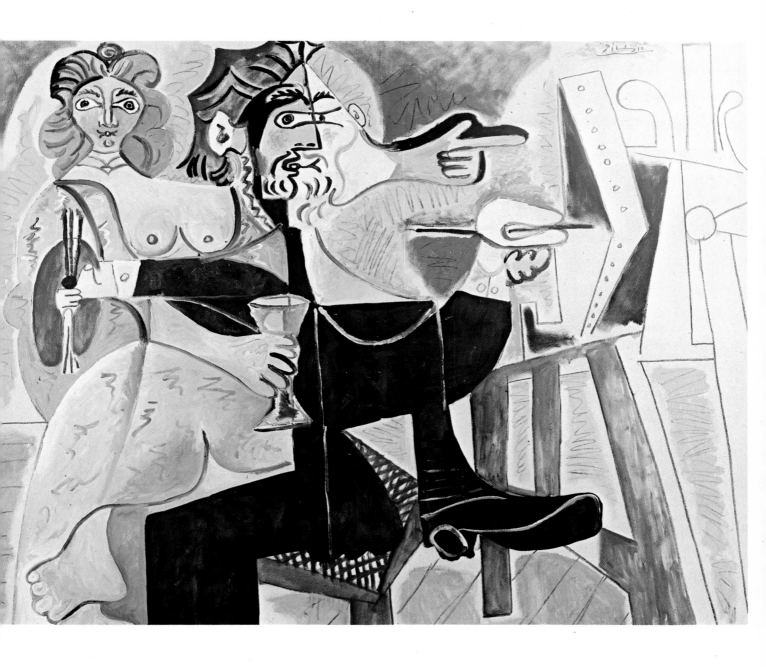

Pablo Picasso: *Rembrandt and Saskia.* Oil, 44½″ x 57¼″. Here is an example of juxtaposing linear and amorphic shapes. Picasso has abstracted his subject in order to capture the essence of pure form. He does this with line, color, and shape. The amorphic shapes are the figures of Saskia and Rembrandt and the linear shapes are the room furnishings and the background area. The soft blues accentuate the submissive mood of Saskia, while Rembrandt is painted in wild, strong blacks and yellows. This canvas superbly illustrates Picasso's ability to combine linear and amorphic forms with perfect mood color. Former collection Saidenberg Gallery.

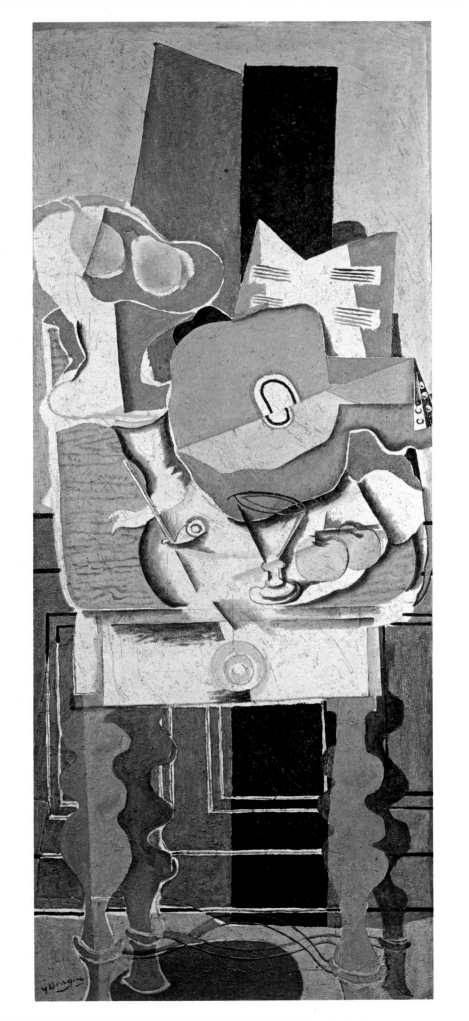

Georges Braque: *Le Gueridon* (left). Oil, 28¾″ x 70¾″. In this painting, Braque limited his palette exclusively to the earth colors which are, in essence, the toned down variations of the intense primaries. No matter where on the canvas he placed these subdued earths, or next to which hues they are juxtaposed, the painting hangs together in a united flow of harmonious rhythm. Collection, Mr. and Mrs. Daniel Saidenberg.

Attilio Salemme: *Tragedy* (below). Oil, 30″ x 43″. The mysterious ritual mood of the painting stems from the artist's use of a series of bright color planes, each having the same dramatic intensity because of their closeness to the primaries. These ungraded areas, painted in flat brush strokes, form the background setting for the superimposed figures. The brilliant colors, which the painter carefully mixed beforehand, creates the even flowing movement, because they are of the same intensity, and they allow the eye to skip from color to color and then back to rest in the large, massive spaces of the background. Collection, Mrs. Attilio Salemme.

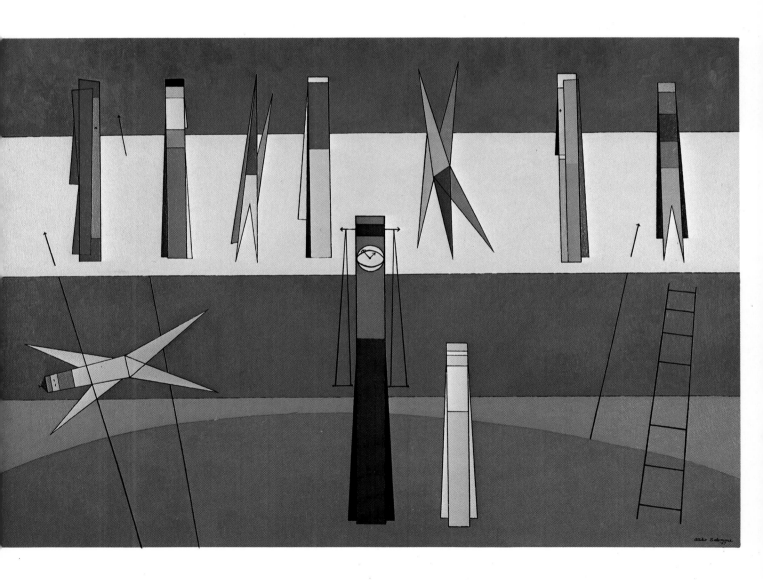

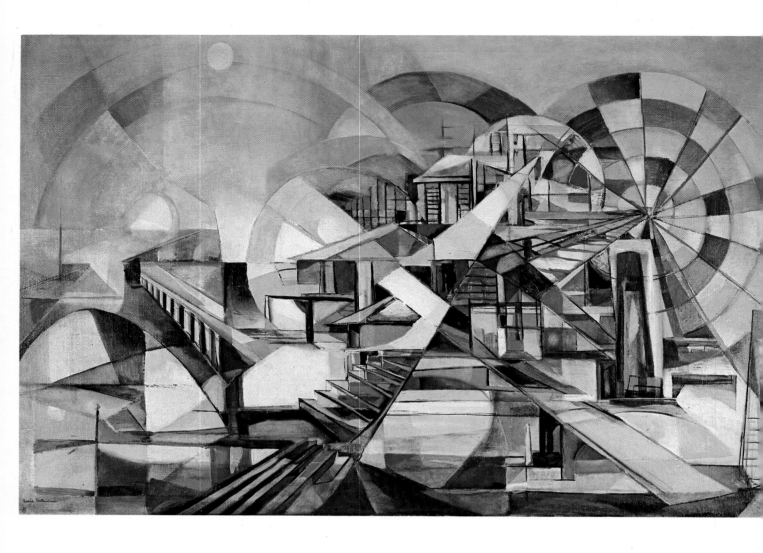

Lucia A. Salemme: *Coney Island*. Oil, 34″ x 52″. In dealing with two and three dimensional problems, you'll be called upon to create optical illusions with color. The term two dimensional refers to the length and width of the flat surface of your canvas. The third dimension refers to the illusion of space or depth created by the way you use color in your composition. In this painting, the colors create a great deal of this illusion of depth, notably in the way the blues and cool reds recede, and the warm yellows and whites advance. The feeling of deep space can be created by the use of color alone. Collection of the artist.

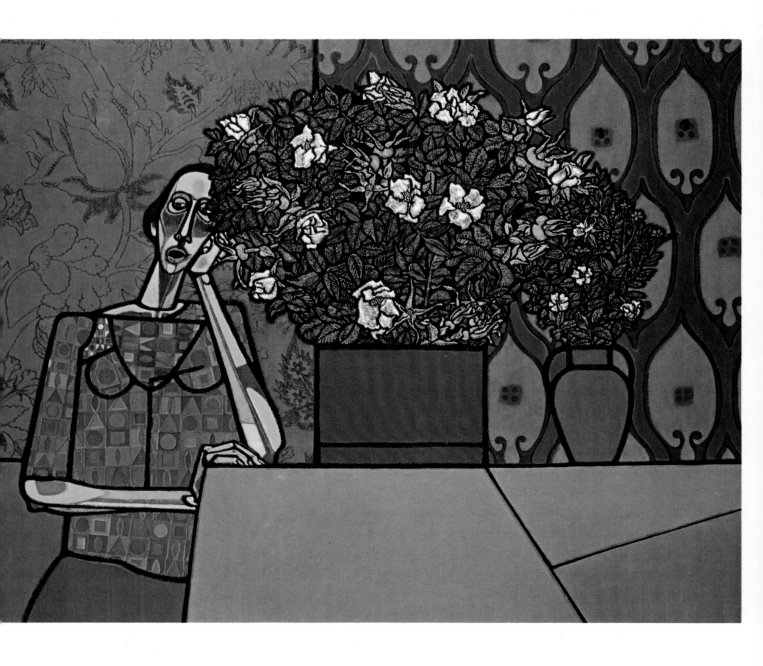

Robert Gwathmey: *Wild Roses*. Oil, 30″ x 40″. An atmosphere of profound serenity is achieved by the use of the soft mauves, gray-greens, and blues, all half-tones in which the artist has chosen to paint the canvas. The black linear encased forms of the quiet figure resting her arm on the table and the compact bouquet of flowers, further enhance the mood already projected by the colors. Courtesy, Terry Dintenfass, Inc.

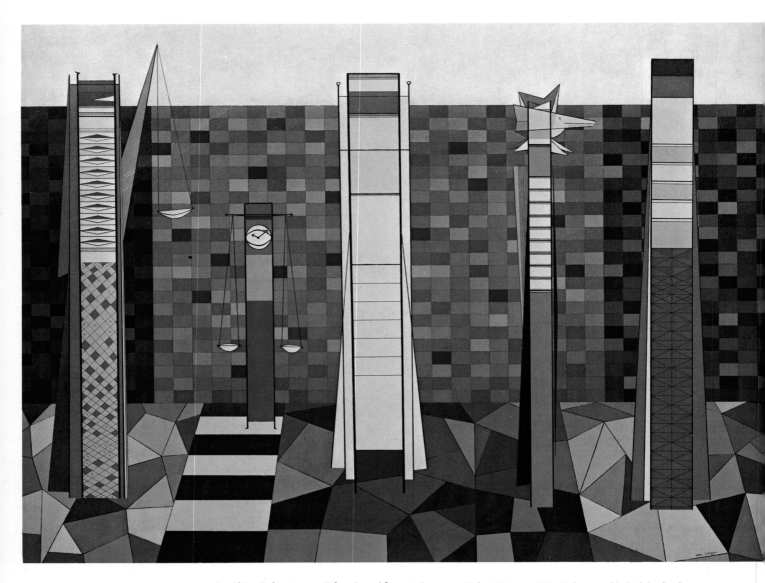

Attilio Salemme: *The Sacrifice* (above). Oil, 60″ x 80″. The wall behind the figures is divided in three sections: the center portion is red and the ends deep grays. The red and gray bricks are all different from each other. Instead of using ten or twelve different reds and scattering them, the artist mixed each one separately, and the same for the grays. The reds now have a strange quality. They blush with the light sometimes in a deep crimson toward purple and at other times toward the orange of cadmium. When the painting is seen up close, the wall flattens the figures to it, but at the proper distance (thirty or more feet), the space between and behind the figures is very strongly alive and felt. Collection, Mrs. Attilio Salemme.

Alexej von Jawlensky: *Helene with Red Turban* (right). Oil, 36½″ x 31¼″. Here, the artist has combined warm and cool colors. Since warm and cool colors together can't help but suggest animation, a somewhat similar effect—but on a lower key—is produced when these colors have been subdued. As shown in this portrait, the red has been neutralized by the addition of some blue; likewise, the blue has been neutralized by the red showing through. The final effect is a strangely restrained and muted animation. Collection, Solomon R. Guggenheim Museum.

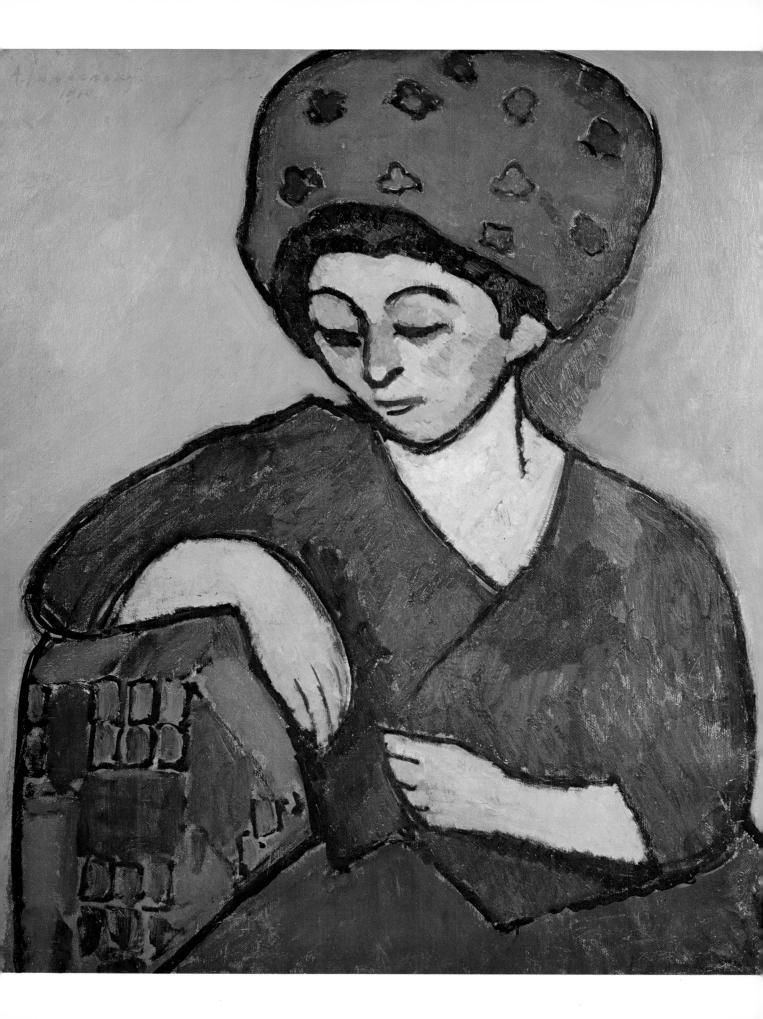

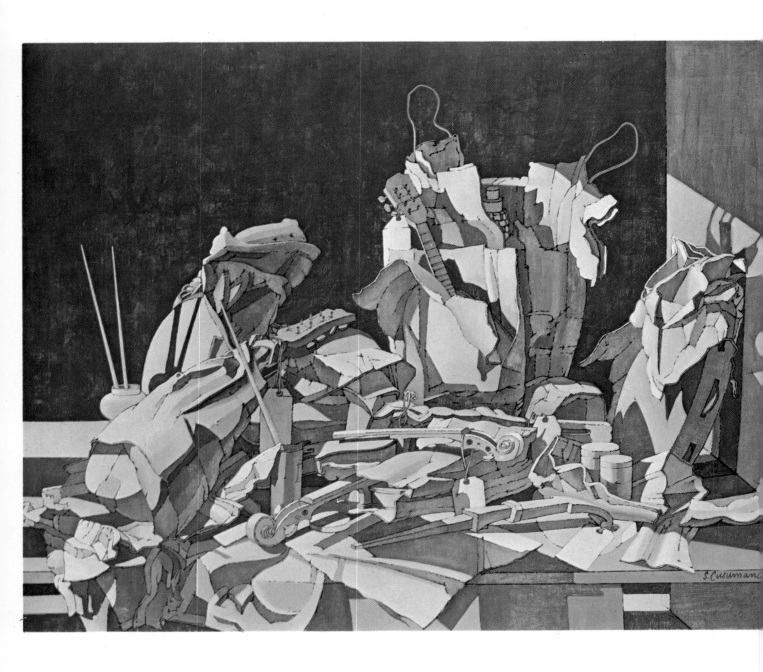

Stefano Cusumano: *Violin Maker's Bench*. Oil, 40″ x 60″. The dramatic distribution of the pure black and white spaces in a painting create the quality known as chiaroscuro. Here, this quality is emphasized by an atmospheric light source which dramatically spotlights the forms of the composition. The sharp lights and shadows of the different objects on the bench create a staccato-like rhythm which reiterates the theme of the subject. Courtesy, Terry Dintenfass, Inc.

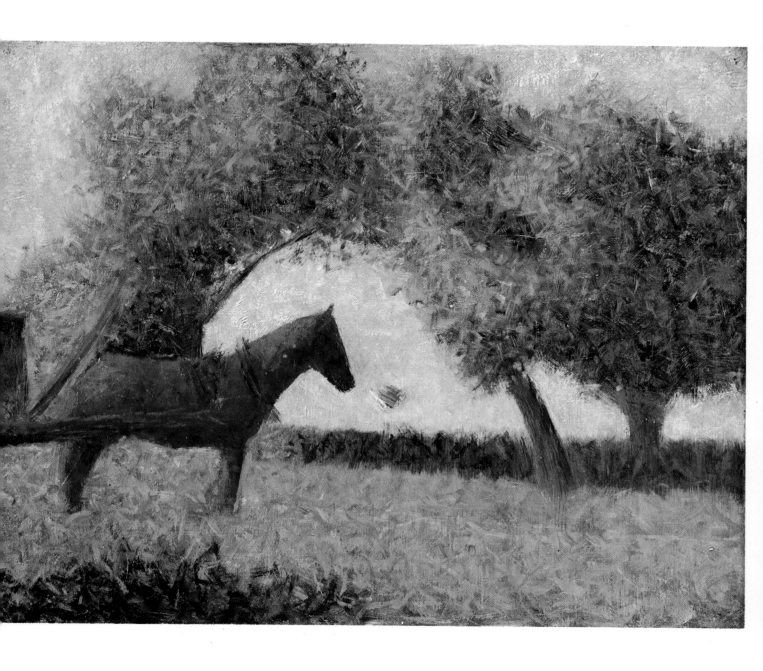

Georges Seurat: *Horses.* Oil, 12¾″ x 16⅛″. This is a fine example of Seurat's remarkable pointillist technique. By breaking up color tones into their constituent elements, he produces a luminous optical mixture far more intense than those mixed on the palette. In this painting, the reflections *within* the colors create a scene shimmering with light and movement. Collection, Solomon R. Guggenheim Museum.

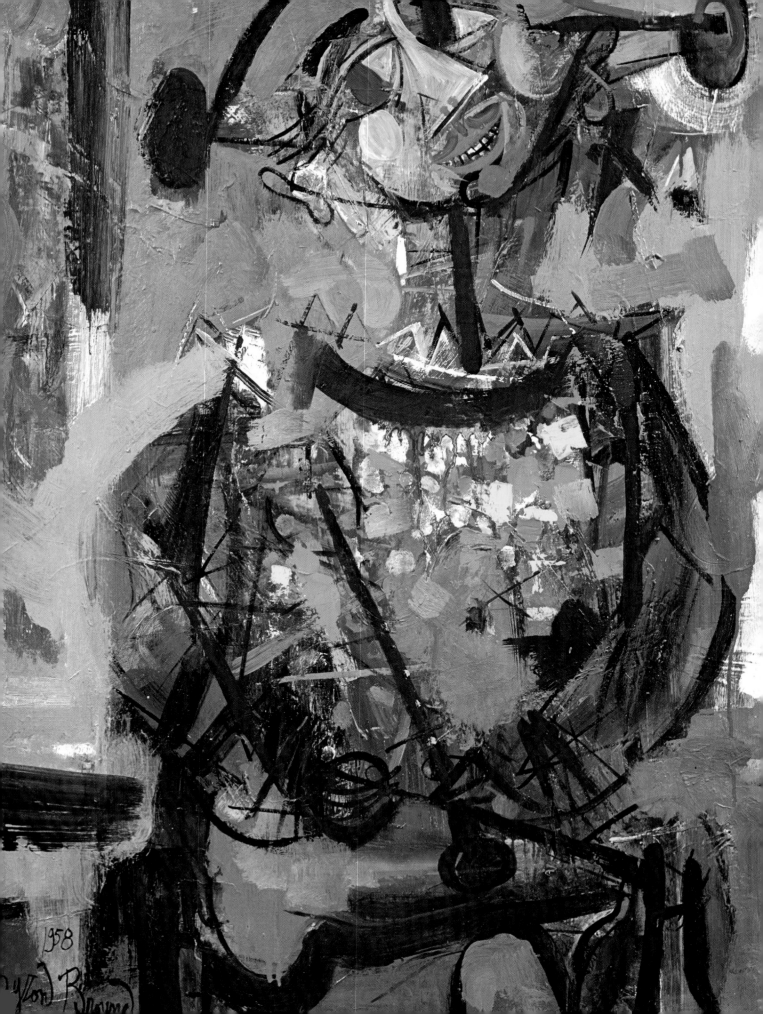

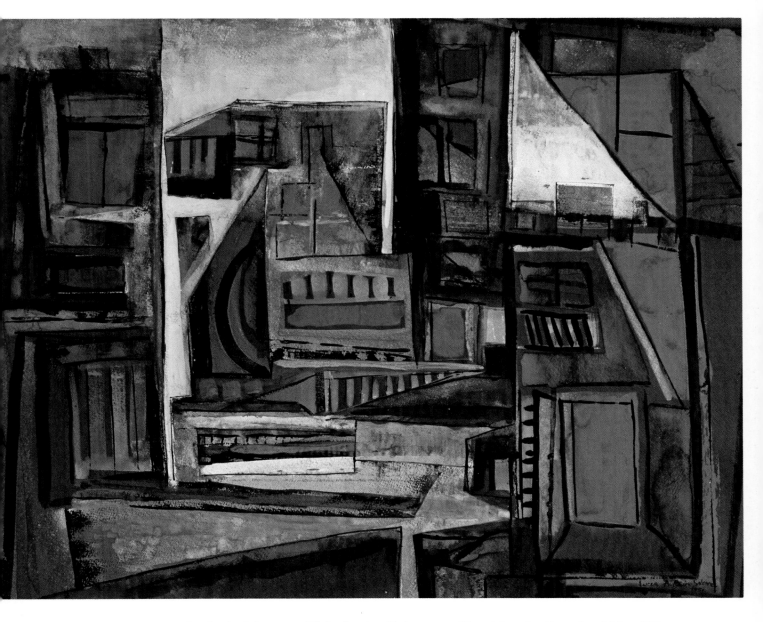

Lucia A. Salemme: *Night in the Clairvoyant City* (above). Gouache, 18″ x 24″. The meditative mood in this painting is produced by the value variations of the blues, along with muted versions of the yellows and reds. The dramatic use of pure white and black areas, placed in key spots of the composition, help accentuate the poetic aspect of an otherwise severe architectural subject. Collection, Whitney Museum of American Art.

Byron Browne: *Clown* (left). Oil, 38″ x 30″. The beautiful textures that appear in this painting were produced with the scumbling technique, a method of dry-brush painting using paint undiluted in medium. This technique is generally done over a dry ground color and the new colors are applied or scumbled in opaque or semi-opaque layers over it. In the painting reproduced here, the artist allowed some of the original color to show through the main subject, thus producing a beautiful archaic effect. Collection, Mrs. Byron Browne.

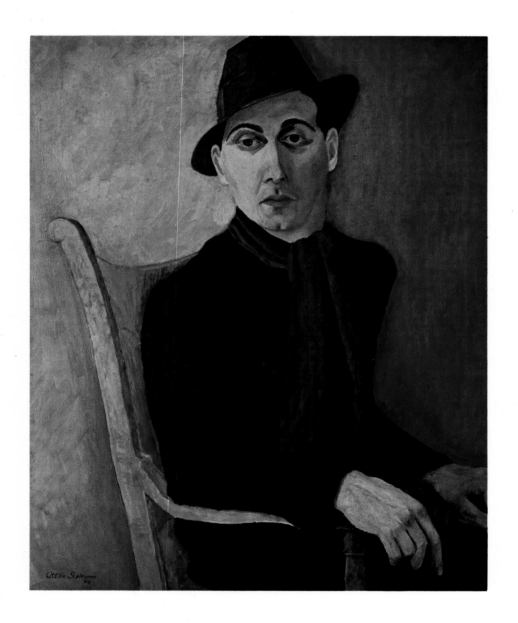

Attilio Salemme: *Self-Portrait 1940* (above). 25″ x 20″. Although the face in a portrait is the positive area, this space will have far greater impact if you tone it down, rather than accentuate it. In Salemme's portrait, the key color is on the face, but the artist modified it by blending some of the background color into the shadow side of the face and some of the flesh tone into the background color. This interchange helps create the illusion that both areas are present in the same atmosphere. Collection, Mrs. Attilio Salemme.

Attilio Salemme: *Ipso-Facto and a Little X* (right). Oil, 40″ x 30″. The color scheme of muted gray-blues, gray-reds, and gray-mauves, combined with the technique of applying the paint with smooth brush strokes, intensifies this artist's poetic ideas. By placing his symbolic personages in balanced vertical stances, he accentuates the gentle mood of the color and creates a feeling of stability and great dignity. Collection, Mrs. Attilio Salemme.

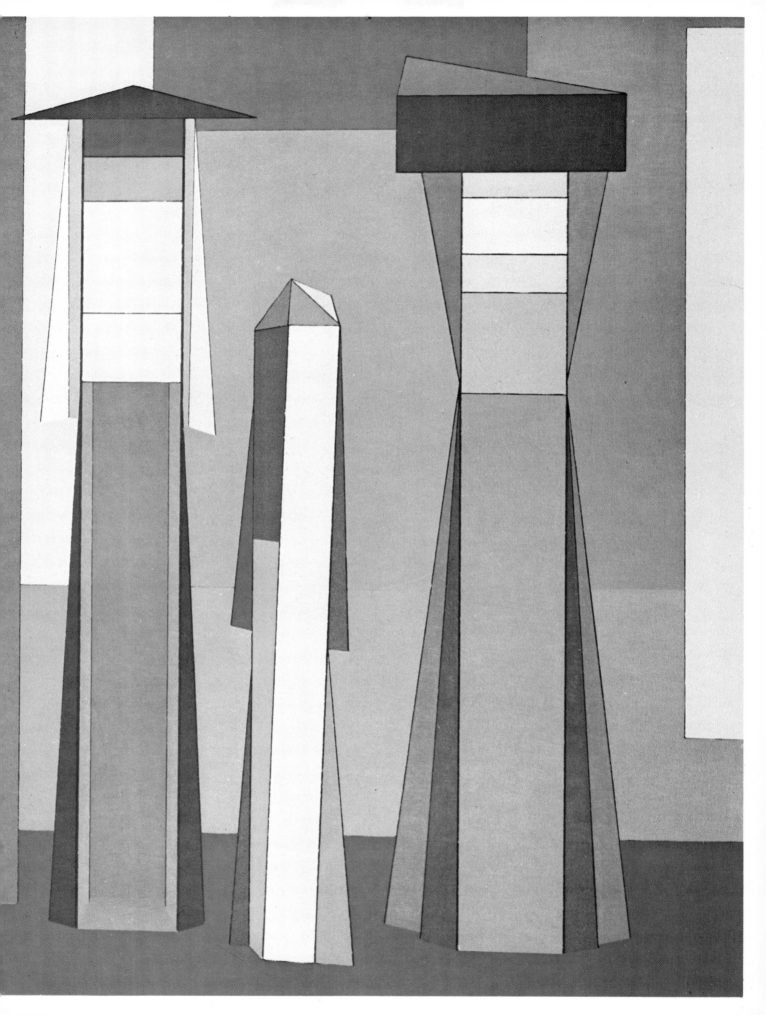

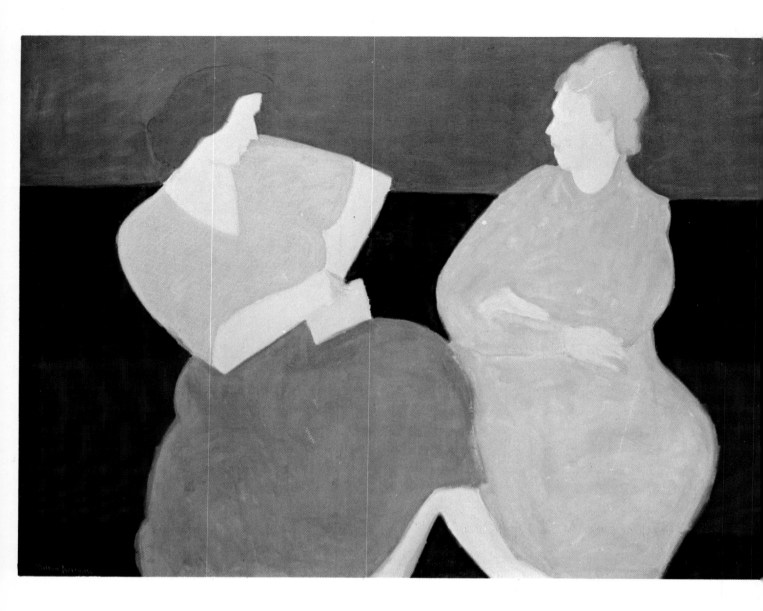

Milton Avery: *Conversation* (above). Oil, 40″ x 50″. Although the forms in this painting are realistic, the artist has broken up the space in a very abstract manner. The colors accentuate this abstract quality and are a very important element in the composition. Note how the muted color of the background spaces and the gentle mauves and blues intensify the quiet mood of the two figures deep in conversation. Collection, Museo de Arte de Ponce, Ponce, Puerto Rico. Donated by the Chase Manhattan Bank.

Paul Klee: *Runner at the Goal* (right). Watercolor and ink, 9⅛″ x 11⅞″. The figure is made up of gentle, flat areas which the artist has painted in cool grays, greens, and blues to emphasize the mysterious mood of the lone running figure. Notice how the background area is a series of stripes of values, running from the deepest value of a blue-gray to the lightest value of a creamy gray. Collection, Solomon R. Guggenheim Museum.

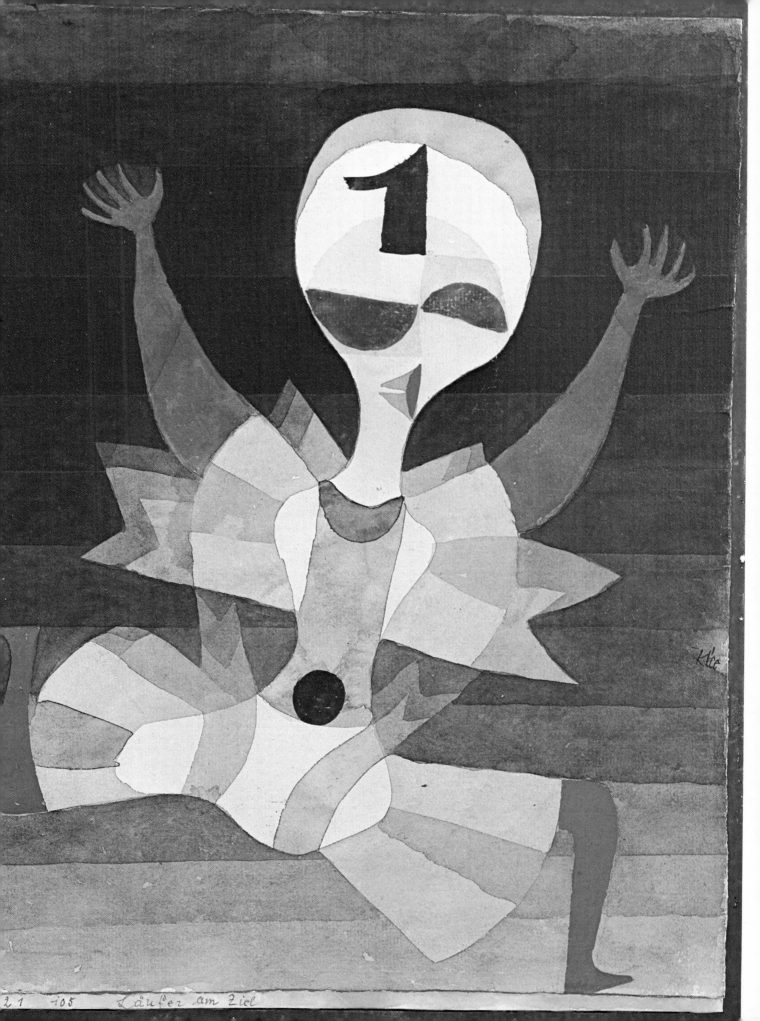

21　105　Läufer am Ziel

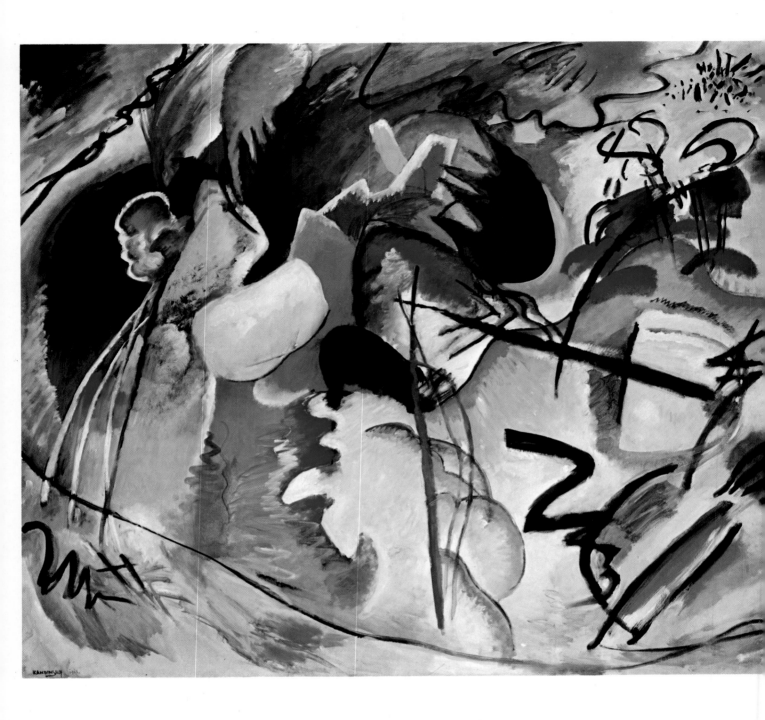

Vasily Kandinsky: *White Form in a Landscape.* Oil, 47⅜″ x 55⅛″. Every color area in this painting is a link that relates to the color next to it and together they make up the total design. This chain reaction of color is what ultimately establishes the unity of the design and gives movement to the composition. Collection, Solomon R. Guggenheim Museum.

114

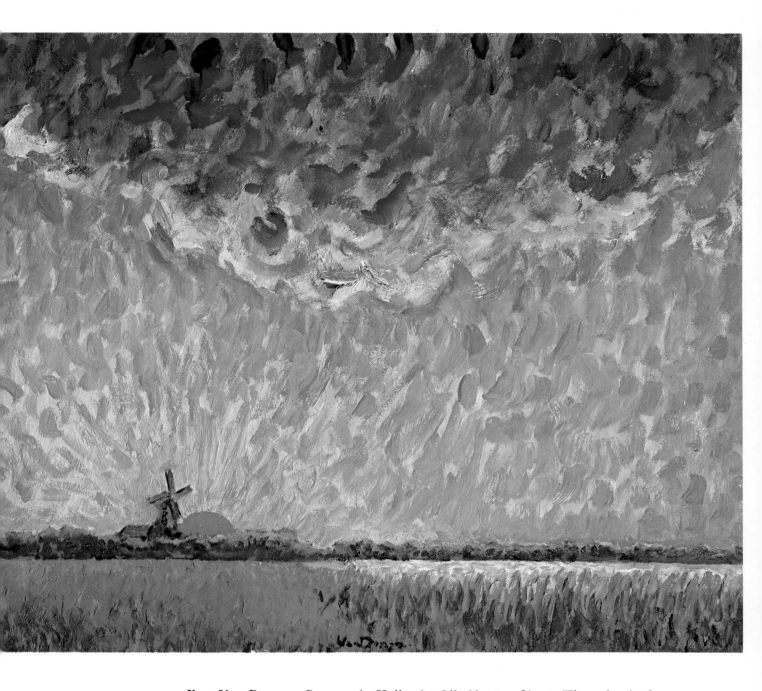

Kees Van Dongen: *Paysage de Hollande*. Oil, 18⅛″ x 21⅝″. The color is the first thing we see when we look at this brilliant rendition of a glowing landscape at dusk. However, there are other elements that help the picture to tingle with life, producing various tensions that are simultaneously interacting with one another. The first is, of course, in the choice of the complementary colors red and green, which are placed over an evenly proportioned horizontal picture structure. In turn, these colors are complemented by the use of visible brush strokes that go in a vertical direction, opposite to the horizontal lines of the composition. Each element, therefore, by complementing the other, revitalizes the whole, creating the total vibrating effect. Courtesy, Acquavella Galleries, Inc., New York.

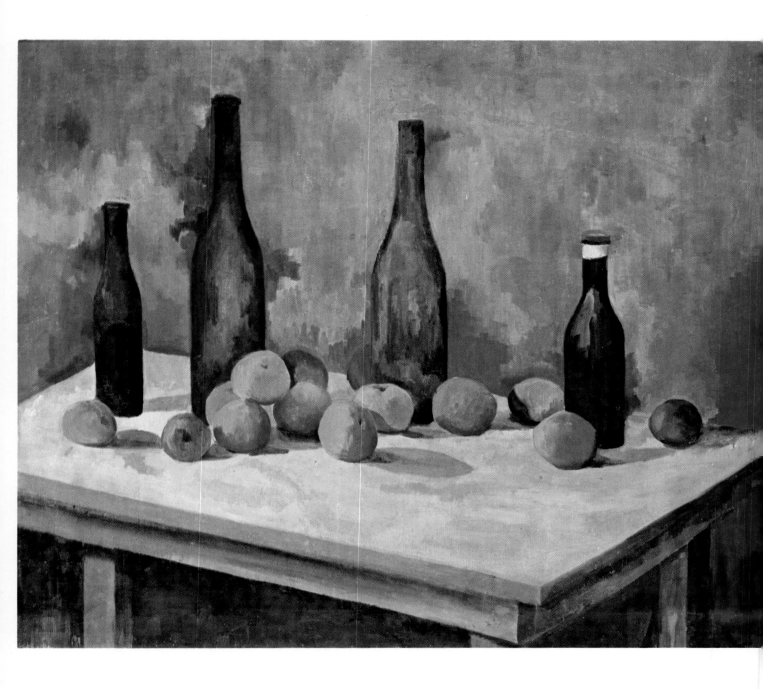

Attilio Salemme: *Still Life with Wine Bottles*. Oil, 20″ x 25″. The key colors in this composition are the warm reds of the background, the orange fruits, and the greens of the wine bottles. Being complements, these adjacent colors tend to activate each other by their proximity, making both colors vibrate with life. All the areas seem to be illuminated by an inner glow, produced by the artist's unerring use of pure color. Collection, Mrs. Attilio Salemme.

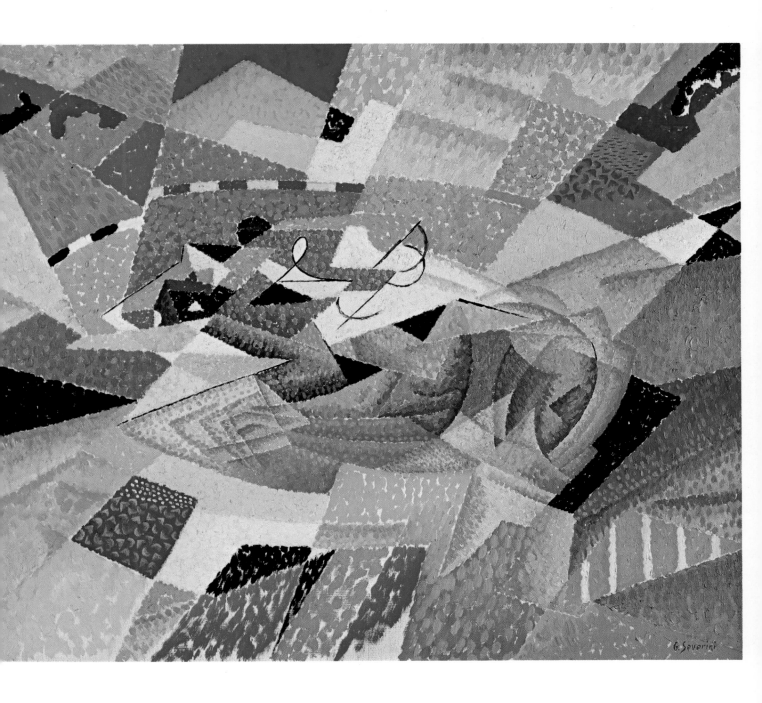

Gino Severini: *Courses à Merano.* Oil, 19¾″ x 24″. A patchwork of subtle landscape forms, sky, hills, lakes, and houses, each painted in its own fresh color, is greatly enhanced by having been enclosed in a definite shape which is carefully juxtaposed to another one of equal individuality. The colors relate to each other because there are no small details to distract the viewer. These small units of color painted in a modified version of the pointillist technique (that is, large visible dabs of juxtaposed warm and cool colors), determine the ultimate unity in this composition. Courtesy, Acquavella Galleries, Inc., New York.

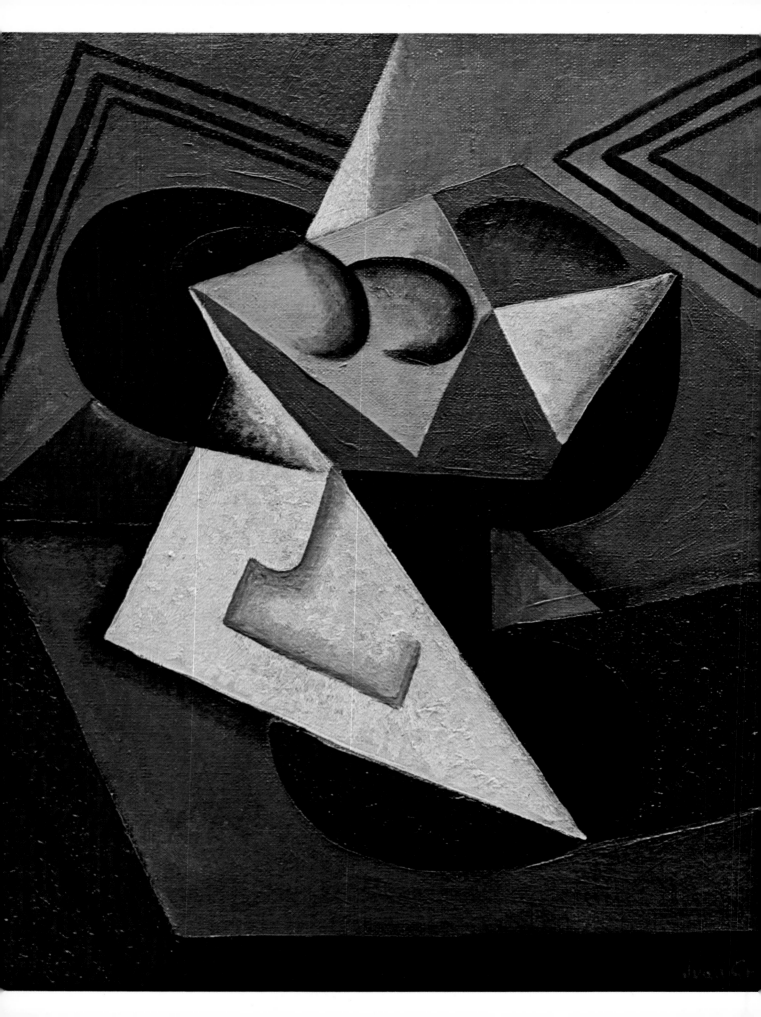

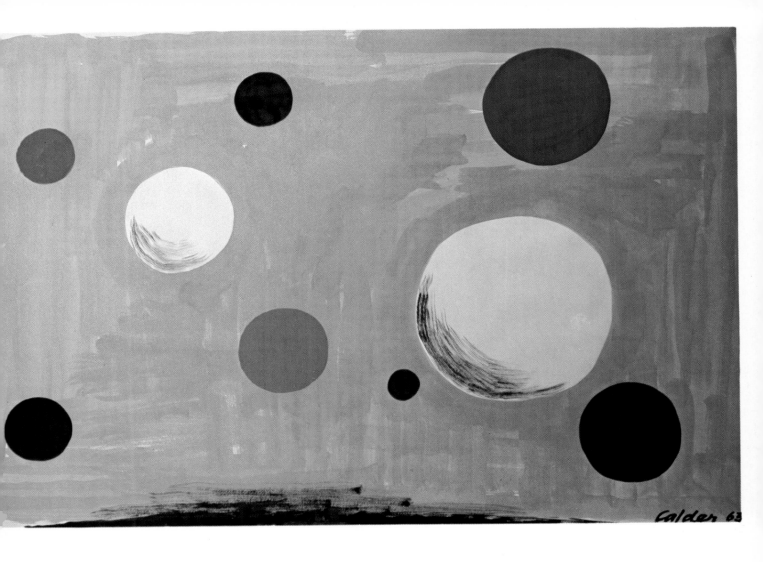

Alexander Calder: *Shaded White Planets* (above). Gouache, 26″ x 40″. In this remarkable painting, the artist has created poetic depth by the way he has counter-balanced both the light and the dark forms over a surprisingly receding yellow background. The over-all effect is one of constant motion, as your eye shifts back and forth and over and into the canvas. The sizes of the different shapes change, depending on which color they're painted in. The big shapes appear even larger when painted in a light color, and the smaller areas look much smaller painted in a dark color. Courtesy, Alexander Calder.

Juan Gris: *Nature Morte aux Fruits* (left). Oil, 17¼″ x 14½″. A feeling of far-off distance and nearness is seen in this abstract painting of a still life subject. Although the objects are painted in flat surface planes, the continuous background running behind the elements in the foreground gives depth to the subject in the composition. The sharp contrasts between the light and dark areas also help in achieving the effect of deep space. Collection, Saidenberg Gallery.

Lucia A. Salemme: *Early Morning* (above). Oil, 40″ x 30″. For a harmonious, uncluttered effect, apply thin coats of paint. In this painting, the entire canvas was first covered with a ground color of thin coats of light mauve. Next, the artist worked and mingled the other color variations without previously having mixed them on the palette. This is known as the wet-on-wet technique, ideal for achieving spontaneous effects that express a carefree· mood. Furthermore, since the paint is applied thinly, the surface does not crack and is easy to clean. Collection of the artist.

Pierre Bonnard: *Dining Room on the Garden* (right). Oil, 50″ x 53⅜″. You can create scintillating effects by selecting colors which electrify each other, producing what is called the plastic quality in a painting. This quality is aptly portrayed in Bonnard's painting shown here. By placing a hot color next to its opposite cool partner (the orange wall next to the blue of the sky, and the yellow platters placed onto the violet table cloth), he has created interactions of colors that cause them each to tingle and to scintillate. Since these colors are opposites to one another, they create a series of tensions that encourage the eye to shift back and forth from one color to another, thus achieving the quality of plasticity. Collection, Solomon R. Guggenheim Museum.

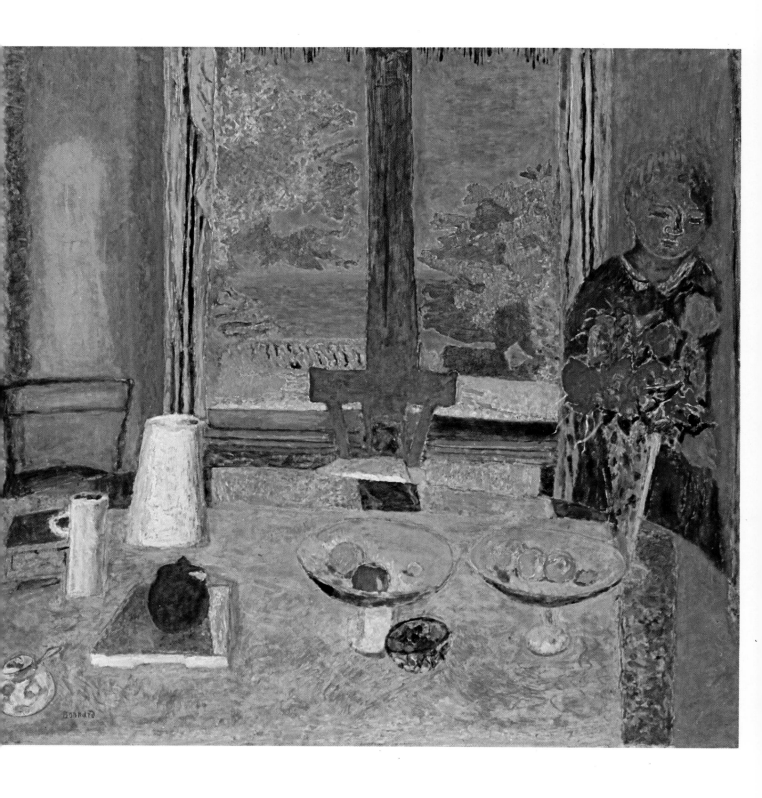

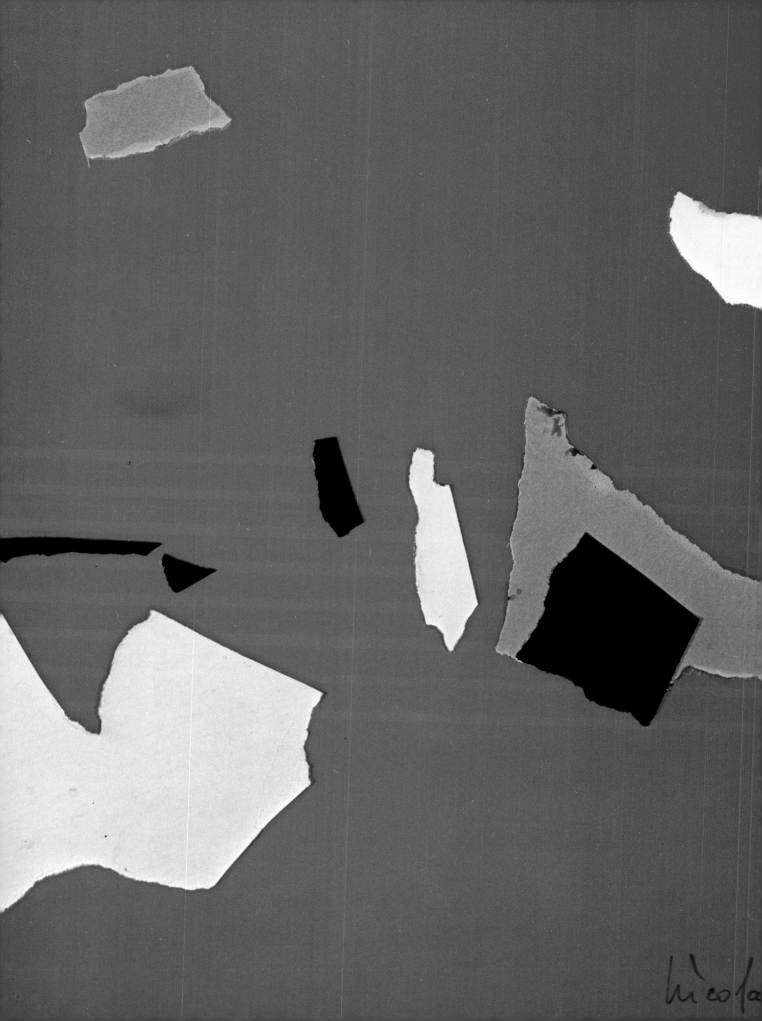

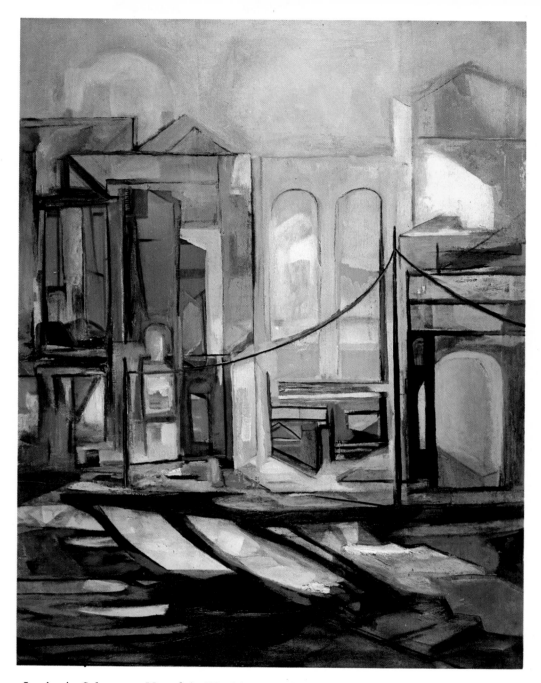

Lucia A. Salemme: *Nostalgic World of Broken Buildings* (above). Oil, 40″ x 30″. There are a group of colors that are lovely to look at when used in a glazing technique. These colors have little solidity, having no pigment quality or body substance. However, when they are mixed with a little white, the resulting mixtures are lovely, subtle undertone versions of their original hues. Many of these transparent colors were used in this painting, superimposed over a bluish-black preliminary sketch. Collection, Mr. and Mrs. Alexander Calder.

Nicolas De Stäel: *Composition Fond Rouge* (left). Collage, 14¾″ x 11¼″. Colored torn or cut up papers are indispensable for carrying out basic color exercises, because they clarify spatial problems easily. By considering each color according to its dominating area and under the influence of which one you place it next to, you'll be able to easily select pleasing and harmonious relationships. Notice the relationships of color in this collage. Courtesy, Harold Reed Gallery.

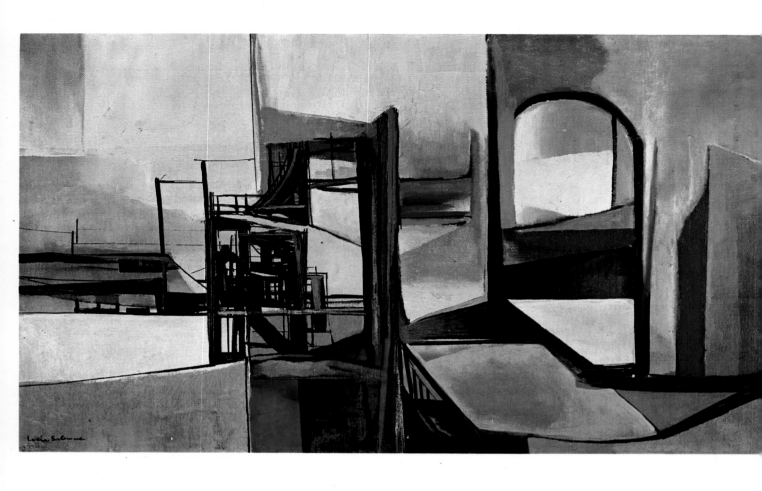

Lucia A. Salemme: *House in the Sun*. Oil, 16″ x 28″. In this painting, both the negative and the positive spaces are of almost equal importance. The positive space is mostly linear, as noted in the bridge structure and open archways of the house on the right. The negative spaces are the surrounding areas and the two fuse together, creating a subjective feeling of quiet serenity. Collection of the artist.

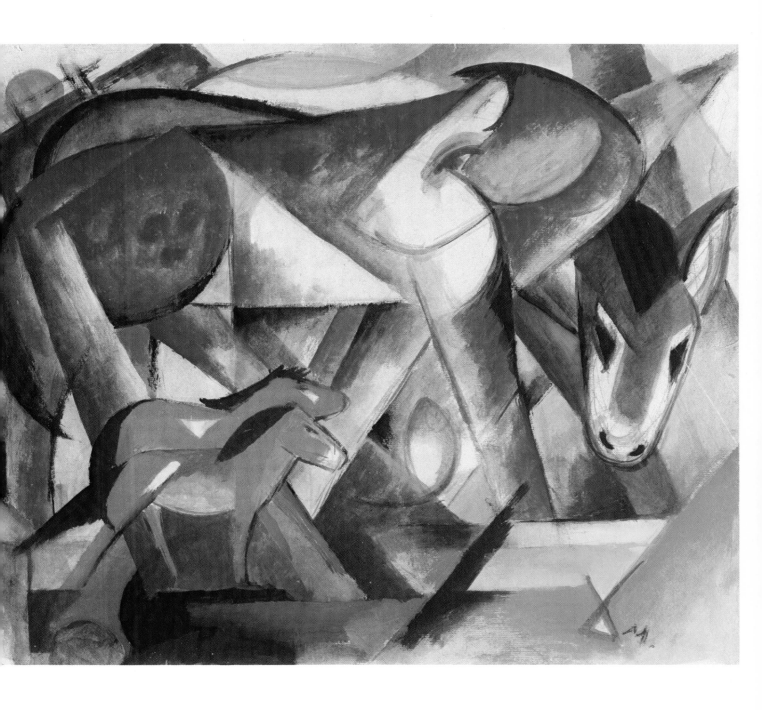

Franz Marc: *Primal Beasts*. Gouache and ink, 15½″ x 18¼″. Notice the plastic quality achieved in this painting by the arrangement of primary colors. A series of bright color planes, which are all equally dramatic, form the setting for this cubist arrangement of the animals in a composition that is both vibrant and arresting. Collection, Solomon R. Guggenheim Museum.

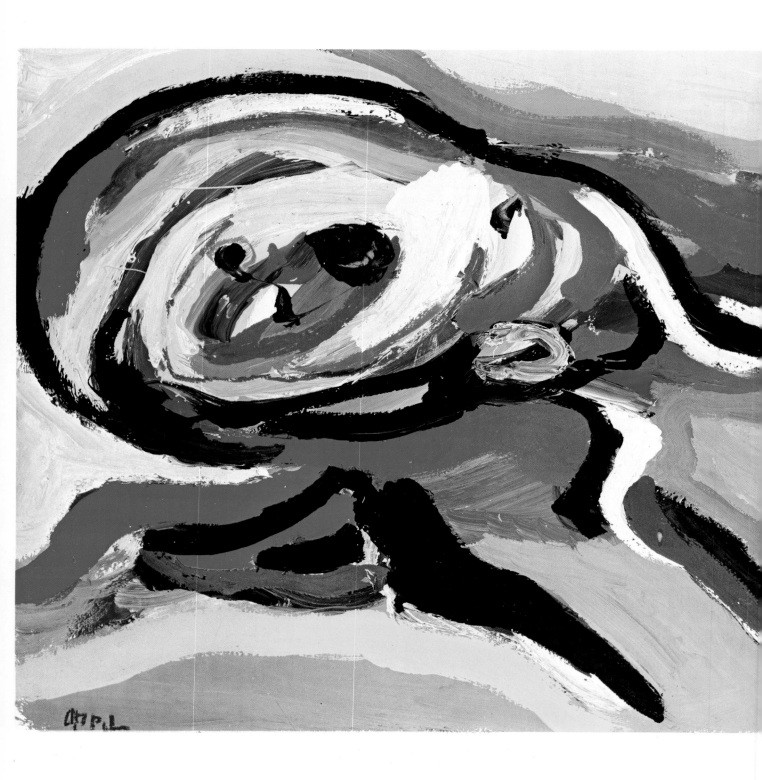

Karel Appel: *Untitled*. Oil on paper, 20″ x 22″. Curved forms express a buoyant mood, as shown by this painting. The circular rhythm painted in black, coupled with the bold mass tone colors, underscore each other, producing an exciting feeling of movement and vitality. Courtesy, Harold Reed Gallery.

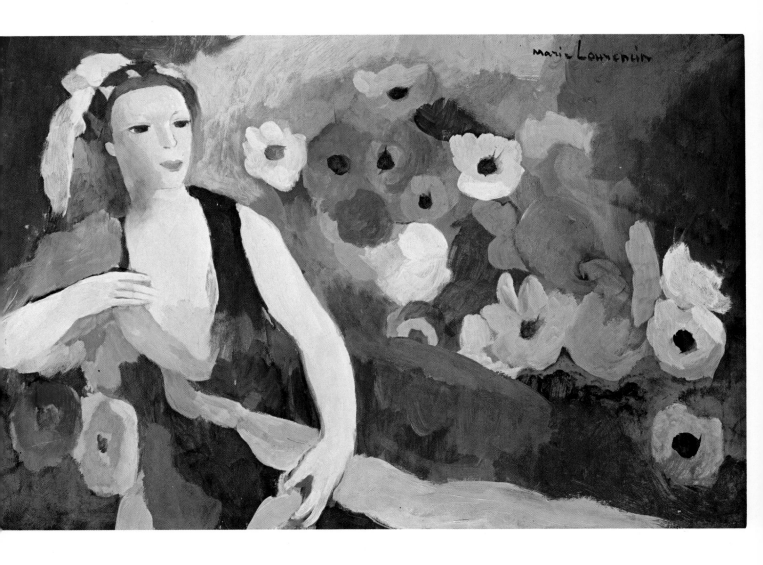

Marie Laurencin: *Jeune Fille avec Anemones*. Oil, 21¼" x 31¼". The canvas is made up of a series of well defined patches of separate color areas, each having gradations that have been previously mixed on the palette. The gradations or values were subsequently worked into each color space with soft, visible brush strokes that appear to be coming from within each color space. Because of the way the artist has arranged the color planes, the completed composition is not unlike a bouquet of flowers. The separate graded patches of color areas exhude an aura of refreshing radiance. Courtesy, Acquavella, Inc., New York. Collection, Mr. Robert Schmit.

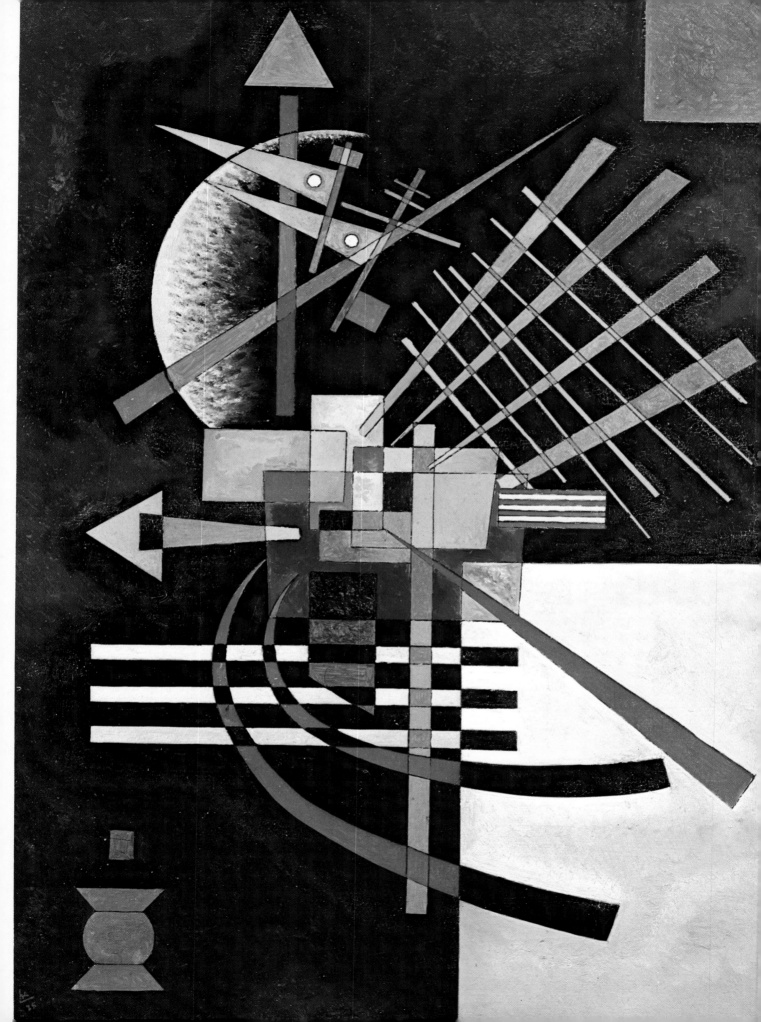

can be seen through the glaze. A glaze is like holding a piece of colored gelatin over another colored area, creating a third color of unsurpassed translucence and luminosity. To glaze with maximum success, it's best to use colors of a darker value over the lighter colors. This is a time-tested principle and the only one that works for this technique.

The first step in glazing is to select a fairly smooth surfaced canvas or one with a fine tooth. Next, apply a coat of white lead paint to the canvas. This pigment provides a permanent anchor for subsequent paint layers, since white lead contains less oil than any of the other artists' pigments. Next, check to see that the canvas is thoroughly dry before you start painting on it. This is to guarantee your getting the transparent effect that is the chief characteristic of the glazing technique.

In order to thin your pigments to obtain transparency, you'll need two small containers, one holding rectified turpentine and the other holding your painting medium, a combination of $\frac{1}{3}$ rectified turpentine, $\frac{1}{3}$ linseed oil, and $\frac{1}{3}$ stand oil, mixed thoroughly. It's a good idea to have these ready as soon as you're ready to start painting.

In the glazing technique, your chief problem is knowing how long it will take for the different layers to dry, since you cannot apply a new coat of paint until the one underneath is thoroughly dry. In order to overcome this problem, you simply add a few drops of cobalt drier to the colors as well as to the medium. One or two drops of this powerful drier added to one inch of paint, or from one drop to one teaspoonful added to the medium will make the painting dry in a matter of hours.

EXERCISE 68: GLAZING DARK OVER LIGHT

The purpose of this exercise is to make you aware of how glazing can affect color. Here we'll make similar colors look different and different colors look similar by superimposing paints. This will help you see the color effects you can achieve with the technique of glazing.

Tools: assorted brushes
canvas board, 18″ x 24″
cobalt drier

Vasily Kandinsky: *Above and Left* (left). Oil, 27⅜″ x 19½″. The narrow bands painted primarily in hot reds and yellows, superimposed over the deeply shadowed red backdrop, sharply accentuate the flashes of heat emanating from the compactly organized, tense composition. It's as if you were looking at the on-and-off flashings of neon lights at night. Collection, Fort Worth Art Center Museum; Gift of Mr. and Mrs. J. Lee Johnson, III. Color transparency, courtesy, Acquavella Galleries, Inc., New York.

COLORS: titanium white
cadmium yellow
cobalt blue
cadmium red

Take a clean canvas, about 18″ x 24″, and divide the space into three sections. Mix light versions of your three primary colors—red, yellow, and blue—by adding a considerable amount of white to each. You now have a pink, a pale yellow, and a light blue, which you apply respectively onto the three separate areas of your canvas. When the surface has dried (in order to speed up drying add a few drops of the cobalt drier or magna medium to your paint), divide each of the three sections into ten equal parts.

Now you're ready to glaze. Remember the rule, use dark colors over light. This explains why we painted the canvas only with light colors.

To make similar colors look different and different colors look similar, paint into each of the ten areas a different glaze made from the colors straight from the tube. For example, apply a green earth glaze to one of the squares on the light yellow, then the same green earth into a pink, and finally onto a blue.

Repeat this procedure with yellow ochre. Now try another glaze, using alizarin crimson. Keep repeating this procedure, using thinned versions of all your colors until you've filled up all the squares. When you've used all the colors in your paint box, you'll see for yourself how the phenomenon of glazing has transformed each of the three colored sections of your canvas into a jewel-like array of translucent colors similar to those achieved by the old masters.

EXERCISE 69: PORTRAIT STUDY OF A BRUNETTE

In this exercise, we'll explore the glazing technique by doing a portrait study.

TOOLS: 18″ x 24″ smooth surfaced canvas
white lead paint
six sable hair flat brushes of assorted sizes
previously mixed medium: 1/3 rectified turpentine, 1/3 linseed oil, 1/3 stand oil, cobalt drier

COLORS: raw umber
titanium white

ivory black
Naples yellow
rose madder
cerulean blue
ultramarine blue
green earth
flake white

Start off your picture by painting in the *light* colors first, gradually adding each successive color of a darker tone. Remember the rule, dark colors over light colors.

First paint your canvas with a coat of flake white and allow it to dry thoroughly. Work in a well ventilated room or outdoors in order to hasten the drying process. Sketch in your subject with a thin wash of the raw umber. Loosely paint in all the shadow areas. Allow this to dry. Next, suggest the background, painting it through to the deep values of the hair.

Mix together ½ white and ½ Naples yellow, thinning this slightly with turpentine, and paint in the entire face, covering the shadow areas previously painted. (Some of this dark should show through the new layer.) Remember, there is no such thing as a flesh tone, because the color of the skin depends largely on what light or atmosphere surrounds it. You can be as imaginative as you like in this color, because the realism is carried out in the drawing. Allow this to dry.

The next day, paint a very thin coat (thinned with your mixed medium) of rose madder over the entire face so that the under color shows through. Allow this to dry. Then apply a thin coat of Naples yellow (thinned with mixed medium) over the entire face and neck areas. Allow this to dry. Next apply a very thin coat of cerulean blue, thinned with your mixed medium, in the shaded areas on the light side of the face.

After this, apply a very thin coat of ultramarine blue added to the areas on the dark shadow side of the face. Allow this to dry. Use green earth to paint in the shadows in the whites of the eyes, nostrils, corners of the mouth. Thin the green with medium, if necessary. Also paint the light side of the hair and allow it to dry. Using raw umber, paint in pupils, eyebrows, and the dark side of the hair, and allow these to dry.

You've arrived at the final stage. You may now use some of the lighter colors wherever you think necessary, most likely in the highlights. Furthermore, you can now use more opaque variations of your colors

to complete the picture. Let me warn you, however, not to be too heavy. Be very selective in how you use your tonal values. Not only are there many shades of each, but the effects vary according to their surroundings, especially according to the adjacent colors. So use your judgment. Work with a light touch and wipe off any excess color with a very soft rag.

The finished picture should sparkle with luminous variations of all your colors!

How scumbling affects color

The scumbling technique is a method of painting with a dry brush, with paint undiluted in medium. This technique is generally done over a dry painting. In other words, the paint must be dry underneath before you apply a new color. This method of painting produces a broken surface texture that is very beautiful. When you scumble, you apply an opaque or semi-opaque layer of paint over a ground color.

EXERCISE 70: SCUMBLING AN OLD PAINTING

In this exercise, our aim is to explore the scumbling technique. At the same time, you will retrieve an old canvas, making it more interesting and poetic.

TOOLS: canvas, 18″ x 24″
one of your old paintings, completely dry
brushes (your old bristles, assorted sizes)

COLORS: cadmium red
permanent green light
cerulean blue
cobalt violet
cadmium orange
yellow ochre
cadmium yellow
titanium white

First study the composition of your old canvas to see how you can improve it. Take out your colors and dry brush into the dry surface with thick paint, dragging the brush back and forth from subject to background. By dragging a new color over the one already there, and

allowing some of the original color to show through, you create a beautiful, archaic, and antique effect. This dry brushing breaks the surface of the color.

Another interesting effect is achieved by scumbling white or a lighter color over a previously painted darker area. You can also soften or subdue a strong color and cover unwanted details. You can obtain interesting textures by applying the color with bristle brushes. Scrape and scratch off paint to reveal the painting underneath. You can use the edge of your palette knife in order to get fine lines by scratching.

Use the less oily colors. Transparent colors, such as alizarin crimson and green earth, are not useful for this technique.

By the time you have scumbled the surface of your painting, you should have an entirely re-created picture.

EXERCISE 71: SCUMBLING A COUNTRY LANDSCAPE

Scumbling is a technique ideally suited for landscape paintings. The atmospheric effects you can create by scumbling are infinite. Let's try a landscape in the scumbling technique.

TOOLS: canvas with a coarse weave or rough tooth
assorted brushes
soft rags
newspapers

COLORS: cadmium yellow
lemon yellow
cadmium red
cadmium orange
permanent green light
cerulean blue
cobalt blue
titanium white

First decide whether you wish your picture to emphasize height or width. If you prefer height, hold the canvas vertically; if width, rest it horizontally. Arrange the shapes; that is, the mountains, sky, trees, and houses, in what you feel is an interesting composition. Avoid having too many things of the same size or shape. Don't put in too much, or too little, and plan for the space *around* the shapes.

Dip your brush in a favorite color and drop it onto some old newspapers which you have placed alongside the palette. Doing this will eliminate and absorb the excess oil that is in the paint, and will further insure your getting your paint as dry as possible.

Roughly sketch in your subject. Paint in all the large masses, such as the sky, meadow, and foreground areas. Allow the painting to dry for 48 hours in a well ventilated room. When the painting has dried, superimpose middle size spaces, such as the trees, barns, or figures, and while the paint is still wet, gently wipe off some of the color so that the underneath color of the dried layer shows through. Allow this to dry for 48 hours.

Now introduce accidental shadow areas, atmospheric effects, or textural elements. Paint in all the details with a small brush, and apply paint in solid patches wherever needed.

When the colors have dried sufficiently, you'll be ready for the next stage, scumbling with rags. Take a small piece of the soft rag and gently rub a transparent mood color over the whole picture surface, say a gray-blue for a poetic mood. Then, while the paint is still wet, rub off some of the parts so that the underneath color areas and details are revealed.

Because of the many superimpositions of color areas, you will have achieved a unique atmospheric effects quite unlike any of those arrived at with any of the other techniques.

Let your eye do the mixing

It's not always necessary to mix the colors you need directly on the palette. By putting one color alongside another—on the painting surface—you will mix these colors *visually* when you view them from a distance. This phenomenon is best exemplified by the pointillist technique. Here, the mixtures are optical. The pointillists broke up tones into their constituent elements, and the resulting optical mixtures produced far intenser luminosities than the same pigments mixed on the palette. The pointillists referred to this as the *Art of Divisionism* because they split or divided complementary colors into the two primary components. For example, instead of putting a green, they put the two colors that make green, blue and yellow, applying the paint in tiny dots as close together as possible. When viewed at a distance, the yellow and blue dots seem to blend making a green.

EXERCISE 72: OPTICAL MIXING

Sea and landscape subjects lend themselves admirably to this pointillistic method of painting, so let's do a country scene by the sea.

TOOLS: canvas board, 16″ x 20″
about nine no. 12 bristle brushes

COLORS: lemon yellow
cadmium yellow
yellow ochre
cadmium red
alizarin crimson
cerulean blue
ultramarine blue
cobalt blue
titanium white
ivory black

Loosely sketch in your subject, dividing the space into three sections for land, sea, and sky. In small dots, paint in all the large spaces first: sky, hills, water. To paint the sky, work from the top of your canvas down in order to avoid smudging any wet areas as you work along. Use a separate brush for each color so that you can quickly interchange the various colors in each area.

Using the pointillistic technique, you'll need a separate brush for each clean color. To get the light of a color, add tiny white dots to the area and black for the shadows, when you want to suggest an orange color, paint in an alternate grouping of yellow and red dots, interspersed with tiny dots of white where you wish to lighten, and black when you want a darker orange. When you want the effect of green fields, paint a series of small yellow, then blue, dots. In order to get the effect of purple, paint a series of small reds, then blue dots onto the space.

Now fill in your smaller areas, such as trees, boats, houses, or figures. Lastly, paint in the details or final accents using a small brush to put in the solid patches wherever they're needed.

When viewed from a distance, all the small points of color will blend together, seeming to become simple color areas, interspersed with myriad reflections, thus creating the effect of a landscape shimmering with light and movement.

Juxtaposing strokes

In juxtaposing strokes, you have another exercise where you use color in its purest sense: no black and white, just color. One color is juxtaposed next to another, creating the illusion of dark and light with clear color combinations. The post-impressionists, and later the pointillists used this method.

Place the color onto the canvas with the palette knife. With the knife, you may squeeze, spread, or tap tiny and broad dabs of clear color onto the surface. You can use the edge of the knife to make lines. Try doing this for yourself and see which method you prefer. You'll see that there are as many styles of palette knife painting as there are styles of penmanship. There are also many types of knives sold in art supply stores to suit the tastes of individual artists. Try them out and choose the one you prefer. I recommend a knife that has a three-inch blade, tapering to a fine point at the tip. This knife takes care of most painting problems.

The technique of palette knife painting is sometimes called the *impasto* technique. It's characterized chiefly by the raised paint ridges which create an additional dimension on the flat surface of the canvas. The thickness of the paint suggests an in-between link between the flat, two dimensional surface of the brushed painting, and the three dimensions of sculpture. Note that the raised ridges of the paint catch the light and cast shadows on themselves, creating the feeling of volume.

Using the juxtaposed paint stroke makes it possible for you to work long hours while the painting is wet. You're able to start and finish a picture in one sitting, simply by juxtaposing stroke next to stroke. You can maintain a clean, orderly canvas and render a clear, crisp image of your subject as long as you wipe the knife clean after each color used. (You'd be surprised how quickly things can get out of hand if you don't get into the habit of wiping the knife!)

The palette knife technique is best suited for expressing mysterious, romantic effects. The accidental effect it produces is part of the fun. You're free to work a play of cool colors against warm. A word of caution about your edges: a hard edge will make your subject look mechanical, so use the sharp edges only where you want attention without mystery. Of course, the reverse is true when you're seeking softer and more poetic effects.

EXERCISE 73: JUXTAPOSING STROKES IN A STILL LIFE

Let's try painting a still life using the technique I've just described.

TOOLS: canvas, 24″ x 30″
two knives, one flat blade for mixing; one trowel-shaped for
applying paint
lots of small rags

COLORS: titanium white
lemon yellow
cadmium yellow
cadmium orange
cadmium red
viridian green
cerulean blue
ultramarine blue
cobalt blue
yellow ochre
cobalt violet light

Loosely sketch in the still life subject with the neutral yellow ochre. Prepare your palette for painting by mixing all the colors you intend using beforehand. Mix ample amounts of each, since you will be using more paint with the palette knife than with the brush.

Using your trowel-shaped painting knife, apply paint to the large areas first. Put down a large blob. With the flat part of the blade, extend the strokes in a consistent direction so that you always have visible ridges. Next, juxtapose adjoining colors, playing light against dark, cool against warm, complements next to primaries, so that you have a festival of colors.

This is no technique for the timid, so paint bravely! If you make a mistake, you can easily scoop it off with your flat knife.

Have the form suggest the direction of the strokes; for example, work the paint vertically on the wall behind the still life, and horizontally for the table top, and in a circular movement for the apples and oranges, until you've finished. The visible ridges of the paint—because they catch and reflect the light—will create another dimension to your colors, enhancing their vibrancy at the same time.

Textural effects and color

When we talk of producing textures, we mean rendering objects in a way that makes their surfaces look different from one another. There is a marked difference between a piece of cloth and a chunk of granite, for instance, but between different fabrics, there is only very little difference in texture. Nevertheless, the difference is there, making it possible for us to distinguish linen from burlap because of the threads constituting the fabrics. Sandstone is different from granite because of the different materials which constitute them. Therefore, when you paint different surfaces, consider the substance the object is made of.

The best way to learn how to render textures with color is to study the real things and to do a series of paintings showing the different structural qualities of their surfaces. These studies needn't be finished pictures to hang in your livingroom. Rather, think of them as a series of important studies which will help you render surface textures in future compositions. Do a series of about two dozen small paintings, each one concerning a different textural problem. Refer to real objects. For the first series, concentrate on organic things, such as leaves, flowers, trees, bark, rocks, and undersea forms (starfish, seashells, fish scales, driftwood, and seaweed). For the second series, study solid forms of land and seascapes, rolling hills, rock formations, trees, mountains, lakes, streams, and the ocean. For the third series, study architectural surfaces, or man-made objects, such as cement arches, pillars, brick walls, steel structures, glass windows, and furniture. For the fourth series, study problems related to portrait and figure painting, such as eyes, hair, flesh tones, drapery, velvet, chiffon, satin, cotton, pearls, diamonds, etc.

With each series, you'll find that different techniques produce different textural results. For example, a linear, visible brush stroke is most effective in painting organic subject matter; for solid forms and landscapes, you'll find the scumbling technique and/or a visible brush stroke with thick application very effective; for architectural subjects, a smooth brush stroke, with little or no ridges is very suitable; for portrait and figure painting, a visible brush stroke with not-too-thick pigment, combined with some glazing, will give you the best results.

Let's try a series of texture exercises with these techniques.

EXERCISE 74: STILL LIFE OF ORGANIC THINGS: IMPASTO

The impasto technique—thick applications of paint—is best suited for this subject. With the paint, you can suggest a variety of textures. Let's explore the technique here.

TOOLS: palette knife
assorted brushes
canvas, 24″ x 30″

COLORS: titanium white
cadmium red
cadmium orange
cadmium yellow
permanent green light
viridian
cobalt violet
ultramarine blue
raw umber
ivory black
alizarin crimson

Select flowers, seashells, and some fruit for your still life set-up. These provide a good variety of organic textures. Arrange the objects· in an interesting group, with the flowers lying on a wooden table top, and the other objects placed around the flowers in a manner that creates an interesting composition.

I suggest the impasto technique for the next phase. Block in the colors of the large areas first, using flat, broad brush strokes. Apply the petals of the flowers, using your palette knife to do this, in sharp, snappy strokes of fresh, clean colors which you mix beforehand on the palette. Then, with your small brushes, proceed to paint the seashells and fruit, following the shape of the objects with the direction of your brush stroke. For example, use a circular action for the round apples and oranges, a horizontal stroke for the starfish. Finally, apply the details with the tip of your palette knife wherever you feel this touch will enhance the textural quality of your painting.

The finished result should suggest the rustic outdoors, ideally produced by the impasto technique.

EXERCISE 75: A TEXTURAL LANDSCAPE: IMPASTO AND SCUMBLING

In this exercise, we'll use our techniques—and all we've learned about landscape color—to give us a richly textured landscape.

TOOLS: canvas, 30″ x 40″
assorted brushes

COLORS: titanium white
cadmium red
cadmium yellow
cadmium orange
cobalt violet light
cerulean blue
viridian green
raw umber
ivory black
yellow ochre

Sketch in a composition that will include flowers, trees, beach, sea, waves, and some people. Use your largest brushes for applying the paint on the large areas, such as the sky, beach, sea. Be sure to keep your brush strokes visible on the canvas. While the paint is still wet, apply additional color, this time with smaller brushes in order to simulate the textures of the different elements in the scene. Use linear, visible brush strokes with generous applications of paint.

In vertical, short brush strokes of raw umber, paint the bark of the trees. Use smooth, horizontal strokes of yellow ochre for the sand, and wavy horizontal strokes of blue and green for the water. Place splashes of white for the sea spray and waves, and small, thick patches of all the bright colors for the flowers. The leaves and branches should be painted in different shades of green.

Wait for about a week for the canvas to dry, and then introduce the atmospheric effects by scumbling some airy violet, green, or alizarin crimson wherever you feel the picture needs it. If you've conscientiously thought about each element as you painted it, and tried to render the surface of the objects as they actually are, I'm sure you'll be pleased with your textural landscape!

EXERCISE 76: A STREET SCENE IN TEXTURE: COMBINED TECHNIQUES

Now let's render the surfaces of different types of architecture, an exercise that will employ all the techniques necessary to convey the various kinds of man-made textures.

TOOLS: sable hair brushes
 canvas, 24″ x 30″

COLORS: titanium white
 cerulean blue
 yellow ochre
 raw umber
 cadmium red
 cadmium orange
 cadmium yellow
 viridian green
 ivory black

Sketch in a street scene, showing a row of different types of structures: a house made of bricks, one of wood, and another of stucco, for example. Also put in a stone wall, windows, and shutters, wrought iron balconies, and a lamp post or two.

As you did in the previous exercise, use a large brush to paint in the large background spaces. Use a smooth brush stroke, with little or no apparent ridges remaining on the canvas. Then, taking one building at a time, apply the colors with medium sized brushes, in order to accurately render the surface textures of each building. Use your judgment for an appropriate technique for each. A small sable hair brush for painting in the final details is preferable.

This exercise has given you the opportunity to work out a carefully detailed, literal subject, in which you can develop your perception of and ability to render the texture of architectural scenes.

EXERCISE 77: A DRAPED FIGURE STUDY: COMBINED TECHNIQUES

In doing a figure study, you'll need to observe the textures of skin, drapery, and hair. The techniques you use will depend on how the different textures appear to you.

TOOLS: assorted brushes
canvas, 24″ x 30″

COLORS: titanium white
cadmium red
Naples yellow
alizarin crimson
raw umber
ultramarine blue
viridian green
cerulean blue
cobalt violet
ivory black

Have your model take a seated pose, then drape her with whatever materials happen to please you, a cotton blouse, for example, or a velvet skirt, a taffeta stole. Remember, this demands that you really concentrate and observe the textures carefully, since your technique will depend on how the different textures appear to you. If you've done all the exercises in this book, you should be able to render these textures effectively.

Mix a little flesh tone with white, Naples yellow, and a bit of alizarin crimson and paint in all the exposed flesh areas. Next, using whatever each color happens to be, paint the background, then the blouse, skirt, and stole.

While the paint is still wet, study the textures of the different features of each area, and simulate it, using a smooth, blended stroke. Indicate the shadow side of the face and arms by gently adding a little raw umber to the flesh tone previously mixed.

The finished painting should be an interesting study of the fabrics and body textures.

EXERCISE 78: TEXTURAL EFFECTS WITH COLLAGE

By doing a collage with the actual materials that come from the earth, you'll be getting a first hand knowledge of their *actual* colors. This will be a great aid to you when you later render them with paint on the canvas surface.

TOOLS: canvas board, 16″ x 20″
flat, smooth colored papers
collage materials
Elmer's glue

Make a selection of assorted still life materials suggestive of a country landscape: all kinds of grasses, woods, bark, feathers, seaweed, leaves, gravel, sand, fish scales, seeds, berries, are some of the materials you might use. Choose them because you like their surface textures.

First sketch in a landscape on your canvas board, dividing the space into three sections, the top space for sky, mountains in the middle, and fields in the foreground. Now separate your materials. Select the flat materials for the sky area; for example, paper, cloth, or leaves. Use the materials that have a fiber or weave for the mountain range, such as bark, leaves, sandpaper, fish scales. Use the thickest of your materials (pebbles and seeds) for the foreground area. For indicating the sky, the smooth materials are the most suitable, and the dull tones are the best colors. Apply the glue to the back of each paper or piece of fabric and press them firmly onto the board. For the middle ground, colored materials with greens, oranges, and violets work best. In pasting down your thick materials for the foreground space, it's best to brush a generous amount of glue onto your panel and then drop or spread the gravel or pebbles onto it while the glue is still wet.

Upon completion of this collage, you'll find that the use of these tangible materials have added another dimension to each spatial area of your picture. Although you've employed lines, shapes, and colors to suggest your subject distance, the addition of these different textured materials has given your picture a much more realistic concept of how to suggest textures. Also, due to the raised surfaces that create varied lights and shadows, these tangible textures pleasantly change the color quality of the different areas in the picture in a very real way.

Creating light effects

Besides learning how to render the textures of tangible objects such as those previously discussed, you'll want to use color and texture to express light effects. In the next few exercises we'll do a series of paintings suggesting different sensations of reflected light: luminous effects (as exemplified in the glow of candlelight or the setting sun on the horizon); lustrous effects (the sheen of all shiny surfaces, such as satin fabrics, steel and chromium fixtures); filmy effects (a foggy day, a smoke-filled room, or a rain-drenched landscape).

EXERCISE 79: PAINTING A LUMINOUS EFFECT

First let's start with an exercise that will help you convey luminous effects, the light cast by the sun, or by a candle, etc.

TOOLS: canvas, 16″ x 20″
assorted brushes

COLORS: titanium white
lemon yellow
cadmium yellow
cadmium orange
yellow ochre
cobalt violet
ultramarine blue

Limit your palette to colors of the same family. For example, if you're painting a landscape at sunset, use white, lemon yellow, cadmium yellow, orange, and yellow ochre. If you're painting a fire on the hearth, use white, cadmium yellow, orange, cobalt violet, ultramarine blue. If you're painting a city skyline at night, use dark blue background with the lights superimposed.

In each of the subjects, you'll be able to show luminosity by creating a definite source of light. For example, in a sunset, the source of light will naturally be the setting sun in the sky; in the fireplace, it will be the actual fire; and in the city skyline, the kaleidoscopic array of lights emanates from neon signs and lit-up windows.

The chief point to remember in each of these subjects is that you *must* indicate the light source. Paint this spot in an extremely light color and gradually shade and grade the other colors from it to its concluding darkness. Next, soften all the edges of each gradation so that it blends into the color it follows. Finally, put a complementary color into an adjacent area, usually the background space.

But try it for yourself and see what a glorious array of colors you will have!

EXERCISE 80: PAINTING A LUSTROUS EFFECT

To achieve a lustrous effect in your painting (that is, the sheen of a shiny surface), you'll use a smooth and sliding technique. With the help of soft, sable hair brushes, you obtain smooth, slick brushwork.

TOOLS: canvas board, 16″ x 20″
 assorted brushes

COLORS: cadmium red
 alizarin crimson
 cobalt violet
 titanium white
 ivory black

Since you'll be called upon to render this effect mainly in portrait and still life subjects, I suggest you take a piece of satin fabric and drape it over the back of a chair, so that the material falls into interesting folds. Limit your palette to colors within the same family, such as all reds (cadimum red, alizarin crimson, violet, and white and black).

First, carefully sketch in your subject to establish the folds in the material. Using a subdued color (any color with a gray mixed into it), paint in the background spaces of the wall behind the drapery. With your pure, vibrant cadmium red, paint in each fold of the drapery. Using smooth, flat brush strokes, paint in the shadow areas on the darks of the drapery, mixing the alizarin crimson and a little black into the cadmium red. Next, superimpose pure and vibrant pink tones over the color which is meant to catch the light on its surface. And last, draw a very thin line of almost-pure white, with only a touch of cadmium red added, to show the extreme sheen of the fabric. You now have a perfect rendering of the shiny surface of a lustrous fabric.

EXERCISE 81: FILMY EFFECTS WITH SCUMBLING

Now let's try painting a filmy, misty atmospheric fog. The scumbling technique is most suitable for producing this effect.

TOOLS: canvas board, 16″ x 20″
 assorted brushes

COLORS: ivory black
 raw umber
 viridian green
 ultramarine blue
 cadmium red
 cadmium yellow
 yellow ochre

First, prepare your palette by mixing a series of dusty hues. Select the key bright colors and then mix them with a little black, white, and raw umber until you arrive at the desired dusty tone. Next, select one of the colors you've just mixed—one that will best express the atmospheric mood you wish to project—and paint the entire canvas with it. If you want variations of this tonal effect, paint in the darker value first and, while the paint is still wet, work some white or any of the lighter values into it.

Now indicate your subject (whatever you desire: a street scene, a landscape, or a figure subject in a hazy, filmy atmosphere). Using a fine brush, sketch in the outline of your subject with any dark color over the still wet canvas. With a larger brush, lightly scrub in lighter values on the sides of objects catching the light. Now put in the details with accents of bright, pure color. These might include such effects as lights from street lamps, shop windows, or faces and clothing of passersby. Use a very small brush or the tip of a fine palette knife for applying your paint.

8 THE FEELING OF COLOR

We all know that our response to color is primarily emotional; that our feelings play a major role in understanding color. Some colors make us feel gay; others create the feeling of sadness, or excitement, or serenity. However, our main concern in these chapters is to learn how to use color; therefore, we have to devise some tangible means of doing so to achieve the full emotional impact of each color.

The first step is to acknowledge the fact that color—all by itself—is a nebulous idea. When you isolate color, eliminating shape or mass, you merely end up with splotches of hues on your canvas. On the other hand, color, when enclosed within a form, further strengthens the structure of the composition. Here we'll explore the way colors enclosed in tangible shapes can express a variety of feelings.

In Chapter 6, "Composing with Color," you've already learned that you can create emotional qualities by the way you place the color and shapes on your canvas. In Chapter 7, you've learned that you can use certain techniques for enhancing the effects you want to achieve with color. In this chapter, we're going to concentrate exclusively on the emotional aspect, creating specific *moods* with color, which will call into play all that you've learned so far in this book. After all, isn't it the final aim to be able to use color for expressive purposes?

Expressing moods with varied techniques

Let's try a series of paintings using varied techniques with colors that will appropriately express the mood you choose to paint. Here are some we will try in the next exercises: happy and gay (wet-on-wet); sad and somber (wet-on-wet); frightening and forbidding (glazing); celebration (heavy impasto).

EXERCISE 82: HAPPY AND GAY MOOD

When you wish to achieve a happy and gay mood, it's best to use the technique of wet-on-wet; that is, laying wet paint into wet paint, as opposed to painting on a dry surface, as you did in scumbling.

TOOLS: assorted brushes
canvas board, 18″ x 24″

COLORS: cadmium red
lemon yellow
cadmium yellow
cobalt blue
viridian

First prepare your palette by mixing a series of bright hues of the reds and yellows. Select your key bright colors and then mix them with white so that you also have a light version of each. Next, select one of the colors you've just mixed—one that will best express the cheerful mood you wish to project—and cover the entire canvas with that color. You can obtain variations in this background color: for *darker* effects in the background, work the unmixed original color into its lighter version; for *lighter* effects, work in more white paint.

Now indicate your subject, the choice of which is up to you, perhaps a landscape, or a figure in a happy, sunshiny setting. Over the still wet ground, freely paint the outlines of the subject, in a bright blue or green. Use a firm, small bristle brush for this step. Lightly scrub in lighter values with a larger brush. This is the area on your subject that is in direct line of the light source, and this touch will give your forms dimension.

Next, using a pure, dark color, accent the details. For this purpose, you may wish to use the tip of a fine palette knife or a small brush. Now that you've completed this final step in the exercise, you should be looking at a very happy mood painting.

EXERCISE 83: SAD AND SOMBER STILL LIFE

Let's try another painting in a wet-on-wet technique, this time to convey the feeling of sobriety and solemnity.

TOOLS: canvas, 18″ x 24″
assorted brushes

COLORS: ivory black
titanium white
cobalt blue
cadmium yellow
cadmium red

Since it's necessary to finish your painting all in one session, plan to devote a full day to your work in this exercise. To create a sad and somber mood, you'll be using a graded scale of gray values. This means seeing your subject in black, white, and as many grays as possible. Therefore, first using just black and white, mix a series of grays—at least six—two dark grays, two light grays, and two middle grays, plus pure white and pure black. Place these mixtures on the upper edge of your palette. Next, on a clean canvas of about 18″ x 24″, sketch in your subject with a thin wash of one gray.

Quickly paint in the different areas of your still life composition. Make your brush strokes follow the shape of the object you're painting. Each gray area should be clearly distinguished from the other gray forms. When you've painted in all the areas, you will have a picture similar to a black and white print of a photograph. In order to color this in, you will work pure color into the wet painted surface. Squeeze onto your palette a little of each pure color you're planning to use. Then, with a small brush, scrub or work this color into the wet paint. Don't let the color destroy the value already there. Use your judgment. It takes only a little bright color to color the object effectively.

Now, with a clean brush, lightly scrub in lighter values on the sides of objects catching the light. This will give your forms dimension and will also establish a continuity in your composition.

By having restricted yourself to a graded scale of all your grays with a little color worked into each, you have achieved a truly sad and somber mood. And by using a wet-on-wet technique, you have further enhanced the softness of these colors.

EXERCISE 84: FRIGHTENING AND FOREBODING SCENE

In this exercise, the glazing technique will serve you well. Let's do a painting showing a drizzly weather street scene; cloudy skies, rainy weather, fog, and all kinds of smoke.

TOOLS: assorted brushes
canvas board, 18″ x 24″

COLORS: raw umber
titanium white
cobalt blue
cadmium red
lemon yellow
permanent green light

Since filminess is airy and atmospheric, it's used mainly as a background for any solid form within your composition. Remember, the color of the major or large spaces establishes the atmospheric mood in which the smaller, more solid shapes move about. Therefore, first mix a series of dusty hues (any color with a little raw umber and white mixed in). Paint in your background spaces with these dusty hues, as well as the sky and sides of the buildings.

Allow these colors to dry completely and then add all your bright color accents, such as the yellow light emanating from street lamps and shop windows. Allow this to dry, then glaze a little of the yellow in the space surrounding the street lamps and lighted shop windows. The scene of a lonely, deserted street, painted in a gloomy dark color, with small specks of yellow light hazily blended around the isolated street lights will create a mood both frightening and foreboding.

EXERCISE 85: CELEBRATION

In this exercise, the palette knife will be used, since an impasto technique will make the statement loud and strong.

TOOLS: palette knife
canvas board, 24″ x 30″

COLORS: permanent green light
cadmium red
cadmium orange
cadmium yellow
cobalt violet light
ultramarine blue
titanium white
ivory black

Think of a myraid series of fireworks shooting into the sky in a festive celebration. Dab on all the bright colors in spiral rhythms all over the canvas in any order you wish. Since you're using all the vibrant colors on your palette, you cannot help but get a wild, exciting picture. The thick impasto of the paint itself will add another dimension to the surface of your canvas, which will catch and reflect any light cast upon it. This added light will further enhance the excitement and luminosity of the colors.

Rhythm and moods

From the painter's point of view, rhythm is a combination of moving patterns on the canvas which can be used for expressive purposes. Concentrate on the spaces in between the forms of the composition. The spaces in between your subject are where the eye pauses to rest, making these areas important. The colors you paint these spaces are a great help in enhancing whatever mood you plan to express.

These nebulous, in-between spaces begin to take on size and shape when they are viewed objectively and independently, and they will provide an added means of expressing certain mood effects.

If the forms of your subject are spread out over your canvas, separated by evenly proportioned in-between spaces, you'll have a contemplative calm, independent slow-moving rhythm throughout the composition. This, coupled with your choice of color, will greatly enhance a calm mood. Let's do a series of exercises, establishing this concept. We'll start with a calm mood and from there we'll continue to do a whole range of moods, concentrating on color and compositional factors to enhance what we're trying to express.

EXERCISE 86: *PAINTING A CALM MOOD*

To paint a calm mood, I suggest you use an aerial view of a landscape. With this subject, you have plenty of room to put our principle of composition to the test.

TOOLS: assorted brushes
palette knife
canvas board, 24″ x 30″

COLORS: cerulean blue
cobalt blue

ultramarine blue
yellow ochre
raw umber
titanium white
ivory black

First sketch in your subject matter—forest, land, rivers, sandy beach, or whatever you prefer. Then indicate details, such as houses, bridges, trees, or rocks. Paint these in with their individual colors, leaving the spaces in between for the last. Now paint in the in-between spaces with whatever color you feel necessary to retain your calm mood.

The horizontal rhythm you've created with evenly proportioned in-between spaces separating each feature in the aerial view have created the slow-moving rhythm throughout the picture. This, along with your choice of colors, will create the desired calm mood.

EXERCISE 87: EXPRESSING SERENITY

It's a well-known fact that the horizontal line suggests placidity. A sleeping person, the flat horizon in the distant landscape, peace, finality, are all expressed by a horizontal line. The way we use this line, as well as the appropriate color scheme, will give us the calm we're seeking in our painting.

TOOLS: assorted brushes
canvas, 18″ x 24″

COLORS: all your blues
yellow ochre
raw umber
ivory black
titanium white

The colors that suggest calm are basically in the blue family, combined with half-tones of all the other colors. So prepare a palette with these colors. For the subject, I suggest you show a room interior with a reclining figure in repose on a couch.

First draw in your composition, then paint in the largest area first, the small areas last. The large areas are the mood-creating ones, so give special attention to the colors you use there. Clearly define the edges of

your spaces and strive for interesting surface textures, by using a visible brush stroke.

You've created the feeling of serenity because you've used horizontally placed froms, i.e., a horizontal couch, and a horizontal reclining figure in a room interior, and you've colored them in soft blues, mauves, and grays, warm half-tones.

EXERCISE 88: EXPRESSING EXCITEMENT

Just as the horizontal line suggests tranquility, so does the broken staccato line suggest animation, an agitated, excitable mood. Since red is the staccato color, use all your reds straight from the tube. The reds, combined with yellow and blue, create the frenetic, vibrating sensations associated with excitement.

TOOLS: assorted brushes
canvas, 18″ x 24″
palette knife

COLORS: reds
yellows
cobalt blue
titanium white

For subject matter, I suggest an imagined rendering of a flame. Think of fire and heat waves. Sketch the outline of your flame or of several flames. (If you have trouble remembering what a flame looks like, try striking a match.)

Work quickly, applying the paint in thick strokes, using your palette knife. Work from light toward the darker colors, and in sharp strokes.

By using broken and jagged edged forms, combined with the vibrant orange-reds, yellow-greens, violets, and blues for color, you will be able to accurately render the sensation of excitement.

EXERCISE 89: EXPRESSING A BUOYANT MOOD

To express a light-hearted, buoyant mood, think of dome-shaped objects, such as tree tops, bubble-shaped clouds, and arches in bridge structures and open umbrellas in a landscape.

Tools: assorted brushes
palette knife
canvas, 18″ x 24″

Colors: cadmium yellow
yellow ochre
cobalt violet light
cadmium red
cerulean blue
titanium white

Plan a composition, using some of these dome shapes, and lightly sketch them on your canvas. With bold brush strokes, apply the suitable colors in a thick impasto technique. Use all the pure colors listed above and keep to a light color scale.

The finished result should be a joyous, buoyant rendering of a landscape.

EXERCISE 90: EXPRESSING STABILITY

For a painting expressing stability and dignity, think of vertical forms in perfect balances, such as skyscrapers, columns, standing people.

Tools: assorted brushes
canvas, 24″ x 30″

Colors: cadmium red
viridian green
yellow ochre
ultramarine blue
ivory black

For this exercise, use people as subject matter. First make a drawing of a group of three or five figures standing side by side, as if they were waiting for a train. Have them dressed conservatively with hats and gloves.

Then paint each figure in muted colors, using flat, smooth brush strokes. Use flat, gentle colors for the surrounding areas. The combination of the perfectly vertical forms and low-keyed color will create the mood of stability and dignity.

EXERCISE 91: EXPRESSING AN INTROVERTED MOOD

By placing dabs of colors together, you will achieve an altogether different effect from that of the last exercise.

TOOLS: palette knives
canvas board, 18″ x 24″

COLORS: lemon yellow
permanent green light
ultramarine blue
cadmium red
alizarin crimson
titanium white
ivory black

Sketch in a bouquet of flowers bunched close together and enclosed in a vase. Then proceed to apply the paint, using a large, broad palette knife to the background space and to the table top. Next, using a smaller pointed palette knife, apply the different colors for the flowers. You'll see that even though you've been using bright, happy colors, the mood will be introverted, close, frightened, and timid. This is because the flowers are bunched close to one another, with little or no space in between.

EXERCISE 92: EXPRESSING A GRACEFUL MOOD

For a painting which suggests a graceful mood, s-shaped curves—such as waves or dancers in action—are suitable subjects.

TOOLS: assorted sable hair brushes
canvas, 18″ x 30″

COLORS: titanium white
lemon yellow
viridian green
cerulean blue
cadmium red
cobalt violet

Sketch a frieze of figures in action, using the arms, legs, and torsos to create s-curve rhythms. Next, add white to whichever colors you plan to use so that you have light, airy versions of all your colors. Use smooth brush strokes to apply the paint. The flowing movement of the dancing figures combined with light versions of all your colors will create the graceful mood you're after.

The final step

This book has brought you just about as far as any book can. By now you've explored all the aspects of color you need for your work. The rest is up to you. You're on your own. You now have the tools to explore your own unique qualities. Have fun! If, in the future, you find that you've fallen into a rut, you can come back to this book for help; you can repeat the exercises you need to restore the imagination and richness of your palette.

INDEX

Abstract shapes, 41

Acrylics, 17

Adhesion, 20

Appel, Karen, illus. by, 126

Architecture, 140-141; *see also* Texture

Aristotle, 13

Art of Divisionism, 134

Atmosphere, 14; and local color, 67-68; and negative space, 81; by scumbling, 133; clear and sharp, 68; colors for rainy, 68-69; for interiors, 68; hints for effective, 68; hot, 31; meditative, illus., 109; serene, 103; sunrise and sunset, 68; *see also* Mood

Avery, Milton, illus. by, 112

Background, continuous, illus., 118; receding, illus., 119; *see also* Negative space

Balance, and weight, 84; of brilliant colors, 85-86; of size and color, 84-85

Bellin's studio size oils, 17-18

Blending, of tones, 54-55; optical, 134-135; *see also* Juxtaposition; Mixing; Painting techniques

Bonnard, Pierre, illus. by, 121

Braque, Georges, illus. by, 101

Brightness, *see* Brilliance

Brights, *see* Brushes

Brilliance, 14; reduction of, 24

Browne, Byron, illus. by, 108

Brushes, 20

Brush strokes, and canvas, 20; for movement, illus., 97; impasto, 97; linear, 138; loose, 36; smooth, 144-145, illus., 111; to suggest form, 137, 139; *see also* Impasto; Palette knife painting

Calder, Alexander, 84; illus. by, 119

Canceling out, 43-44

Canvas, 19-20

Casein, 17; defined, 14

Chiaroscuro, 55-65; portraits in, 57; illus., 106

Chroma, 14

Cityscapes, 53-54; *see also* Street scene

Cobalt drier, 19, 129

Collage, 17; of values, 52-53; textural effects with, 142-143; three dimensional, 72-73; tools and materials for, 20-21; values in, 65; illus., 122

Color, accents, 24; adjacent, 76-77; advancing, 67, 69-70; analogous, 13-14, 87-88, illus., 98; and composition, *see* Composition; and light, *see* Light; and movement, *see* Movement; Rhythm; and season, *see* Atmosphere; Mood; and shape, 77-78, *see also* Composition; and size, 75, *see also* Composition; and subject, 67, *see also* Atmosphere; Mood; and technique, *see* Painting techniques; and time of day, 67, *see also* Atmosphere; Mood; antagonizing, 88-89; atmospheric, 68; attraction and repulsion of, 70; brilliant, 85-87; background, 70-71; charts, 18; cool and cold, *see* Temperature; complementary, *see* Complementaries; earth, 14, 24-25, illus., 100; electric, 25-26, illus., 121; emotional impact of, *see* Atmosphere; Mood; expanding, 77; gradation of, 23-24, 62-66; harmony in, 39, 87-88, *see also* Harmony; history of, 13; hot, *see* Temperature; linked, illus., 114; list of cold, cool, hot, warm, 27; list of necessary, 18; local, 67-68; matching of, 32; mineral, 15; mixing, *see* Mixing; neutralized and neutralizing of, 45, 94, illus., 105; oil, 15, 17, *see also* Oils; of different families, 76; organic, 15; perspective, *see* Depth; Perspective; Three dimensional; poetic effects with, 79-80; primary, 16, 21-22; receding, 67; relationships, *see* Relationships; scheme, 24, 93; secondary, 16; spatial relationships of, 74; staccato, 153;

subtle, 24-25; temperature of, *see* Temperature; thinning of, 129; toned down, illus., 110; warm, *see* Temperature; weight of, *see* Weight

Color plates, 97-128

Color wheel, 13, 39

Complementaries, 14, 39-50; and rhythm, 44; and size of shape, 43-44; and temperature, 39; canceling out of, 43-44; defined, 39; for landscape, 42-43; harmonious, 41; Impressionist use of, 49-50; inharmonious, 88-89; juxtaposition of, 41-43, 44, 49-56; laying out of, 39-41; list of, 40; mixed, 88-89; plastic quality of, 42; vibration of, 41-42; with half-tones, 59-60; illus., 115, 116, 121

Composition, 74-95; action in, 94; advancing and receding in, 38; balance in, 75; correcting imbalanced, 86-87; defined, 14; influence of color on, 74; over-all, 41; plastic, 25-26; positive and negative space in, 80-83; rhythmical, 34; size of area in, 75; unbalanced, 86; unity in, 80; use of collage for study of, 74; vacant space in, 87

Contour, 35

Contrast, 90-92

Cusumano, Stefano, illus. by, 106

da Vinci, Leonardo, 13

Dead space, 82

Depth, and color, 69; and size, 69-70; echoes to accentuate, 83; in collage, 72-73; in landscape, 71-72; in still life, 70-71; intensification of, 70; illus., 102, 118, 119; *see also* Perspective; Three dimensional

Design, 14; *see also* Composition

De Staël, Nicolas, illus. by, 122

Details, 38

Discord, coloristic, 88-89; in shapes of equal size, 89; in various shapes, 90-91; with mixed complementaries, 89

Distance, *see* Depth; Perspective; Three dimensional

Drapery, 141-142, 145

Drying time, for glazing, 129; *see also* Cobalt driers; Oils

Dufy, Raoul, illus. by, 98

Edges, hard, 136; soft, 72

Expressionists, abstract, 25; German, 25, 42

Figures, 154, 155-156; textured study of, 141-142

Filminess, 150; *see also* Atmosphere; Mood

Flats, *see* Brushes

Flesh tones, 94, 130, 142

Fog, 145-146; *see also* Atmosphere; Mood

Folds, *see* Drapery

Form, 14; colors for advancing and receding, 72; *see also* Composition

Glaze, defined, 14

Glazing, 19; dark over light, 129-131; defined, 126; effect of on color, 126-129; for frightening and foreboding mood, 149-150; procedures for, 129

Glue, for collage, 20

Gouache, characteristics and use of, 17; defined, 14

Graded scale painting, 54-55

Gray, basic, 51; complementary tones of, 49; mixing of, 48; values of cool, illus., 113

Grayed-down, 15

Gris, Joan, illus. by, 118

Ground, *see* Canvas; Support

Gwathmey, Robert, illus. by, 103

Half-tones, 15, 57-61; exercise for, 22-23; mixing of basic, 62; of cool colors, 34; of hot colors, 31; painting in, 57-61; reflecting adjacent color, 61-62; vibrating by combined methods, 61-62; *see also* Mixing; Tones; Values

Harmony, 87-89; and analogous colors, 87-88

Hue, 15; *see also* Color

Impasto, 15; and acrylics, 17; and canvas, 19; for still life, 138-139; for mood of celebration, 150-151; technique of, 136, 154; *see also* Palette knife painting

Impressionists, 49; technique of, 49-50

Inks, 17

Intensity, 15

Interiors, 152-153; *see also* Atmosphere; Mood

Jawlensky, Alexej von, 42; illus. by, 105

Juxtaposition, 76; for visual mixing, 134-135; of complementaries, 41-43, 44-45, illus., 121; of light and dark, 55-56; of linear and amorphic shapes, 83-84, illus., 97; of strokes, 135-136

Kandinsky, Vasily, 44; illus. by, 114, 129

Key, 53; *see also* Values

Klee, Paul, illus. by, 113

Landscape, 42-43; buoyant, 153-154; calm, 151-152; dynamic contrasts in, 91-92; painted in depth, 71-72; in impasto and scumbling, 139-140; rainy, 68-69; scumbled, 133-134; textural, 139-140; values in, 65-66

Laurencin, Marie, illus. by, 127

Light, and color, 67; and dark, *see* Values; juxtaposed with dark, 55-56; effects of, 143-146; filmy, 145-146; luminous, 143-144; lustrous, 144-145; of Rembrandt, 56; source, 16, 42, 58, 144

Line, 15

Linseed oil, 18

Local color, 67-68

Marc, Franz, 42; illus. by, 125
Masonite panels, 21
Mass tone, 15, 64; exercise for, 22-23; of cool colors, 34; of hot colors, 30-31
Materials, 17-21
Medium, defined, 15; described, 18-19
Mixing, by combining methods, 61-62; by matching colors, 32; direct, 32; of complements, 44-50, 59-61; of grays, 48, 51; of half-tones, 59-61 *passim,* 62; optical, 134-135; procedures for, 29; *see also* Temperature; Values
Monochrome, 15
Mood, 147-157; and rhythm, 151-156; buoyant, 153-154; calm, 151-152; dignified and stable, 154; frightening and foreboding, 149-150; happy and gay, 148-149; graceful, 155-156; introverted, 155; of celebration, 150-151; of excitement, 153; sad and somber, 148-149; serene, 152-153; *see also* Atmosphere
Movement, 92-95; and value scale, 94-95; by overlapping planes of color, 94-95; defined, 92; effect of amorphic and linear shapes on, 93-94; free form, 92-93; illus., 119, 126; *see also* Rhythm

Negative space, 15, 81-82; combined with positive space, 82-83; contrasted to dead space, 82; rhythms in, 92; illus., 124; *see also* Backgrounds; Composition; Positive space
Newton, 13

Oils, adhesiveness of, 18; drying of, 19; student grades, 17-18; thinning of, 78-79
Optical illusions, 69
Opaque media, 17
Overpainting, 19

Paint box, 20
Painters' terms, 13-17
Painting techniques, 126-146; combined, 140-142; direct, 32; glazing, 149-150; wet-on-wet, 147-149; *see also* Glazing; Juxtaposition; Palette knife painting; Scumbling; Textures
Paints, choice of, 17-18
Palette, 15
Palette knife painting, 136; for textural effects, 138; *see also* Impasto
Palette knives, 20; described, 136
Paper, construction, 20; transparent, 21; *see also* Collage
Pastels, 17
Perspective, 14, 67-73; *see also* Depth; Three dimensional
Philosophers, Greek, 13
Picasso, Pablo, illus. by, 99
Pigments, 16

Plastic quality, 16, 25-26, 42; in a landscape, 42-43; illus., 121, 125
Plasticity, *see* Plastic quality
Plato, 13
Pointillist technique, 134-136; illus., 107, 117
Polychrome, 15, 16
Portraits, glazed, 129-130; in Rembrandt lighting, 56; positive and negative spaces in, 80-81
Positive space, 16, 80-83; toning down of, 80-81; *see also* Composition; Negative space
Post Impressionists, technique of, 135-136
Pythagoras, 13

Rain, 69-70; *see also* Atmosphere; Mood
Reflections, of half-tones and adjacent color, 61-62; of light, 77
Relationships, between sizes of same color, 75; of adjacent colors, 76-77; of color to shape, 77-78; spatial, 77; *see also* Composition
Rembrandt van Rijn, 97; lighting of, 56
Rhythm, and mood, 151-156; and movement, 92-95; broken staccato, 153; circular, illus., 126; curved, 155-156; from juxtaposition of complementaries, 44; horizontal, 151-153 *passim;* vertical and balanced, 154
Rounds, *see* Brushes

Salemme, Attilio, 44; illus. by, 101, 104, 110, 111, 116
Salemme, Lucia A., illus. by, 102, 109, 120, 123, 124
Saturation, 16
Scumbling, 16, 132-134; defined, 132; for filmy effects, 145-146; for landscapes, 133-134; for solid forms, 138; over an old painting, 132-133; with rags, 134; illus., 108
Seurat, Georges, illus. by, 107
Severini, Gino, illus. by, 117
Shade, 16
Shadows, 42-43, 57
Shapes, amorphic, 93-94; and color, 76, 77-78, illus., 119; effect of on movement, 93-94; linear, 93-94; linear and amorphic combined, 83-84, illus., 99
Size, and color, 75; balancing of, 84-85; effect of values on, 78
Solidity, of forms, 72
Space, rendering illusion of, 54; *see also* Depth; Perspective; Three dimensional
Stand oil, 18
Still life, 78-79; floral, 155; painted in depth, 70-71; painted with palette knife, 136-139; sad and somber, 148-149; wet-on-wet technique for, 148-149
Street scene, textured, 140-141
Support, 19-20
Surface, glossy and matte, 19

Techniques, *see* Painting techniques

Tempera, *see* Gouache

Temperature, 27-38; and complementaries, 42, 39; cold and cool, 14, 32-37; defined, 27-28; hot, 30-31; introductory exercises for, 28-30; relativity of, 28; tonal scale of hot, 30-31; warm, 17, 35-36; and cool combined, 37-38; compared with hot, 35; illus., 105

Texture, 137-143; by impasto, 138-139; and scumbling combined, 139-140; defined and described, 137-138; expressing moods with, 147-157; organic, 139; studies for, 138; techniques for, 138; satin, 145; scumbled, illus., 108; to express light effects, 143-146; with collage, 142-143

Three dimensional, 16, 54-55, 67; *see also* Depth; Perspective

Tint, 16

Tones, blended, 54-55; half-tones, 57-61; vibration of, 58-61; *see also* Half-tones; Mass tones; Mixing; Undertones; Values

Transparency, 16

Turpentine, 18; rectified, 18-19; *see also* Glazing

Two dimensional, 16, 67

Underpainting, 16-17

Undertone, 17; exercise for, 22-23; of cool colors, 31; of hot colors, 31

Values, 17, 23, 51-66; and key, 53; and movement, 94-95; and shadows, 57; collage of, 52-53; defined, 51; distinction of, 51; effect of on size, 78; graded gray, 149; half-tone, 62-63; in a collage, 65; in gray cityscape, 53-54; in landscape, 65-66; middle, 63; mutual effect of, 52-53; of all colors, 62-63; of gray, 51-52; of pure colors, 64; overlapping planes in similar, 94-95; range of, 62-66; *see also* Mixing; Tones; Undertones

Visual balance, *see* Balance; Weight

Van Dongen, Kees, illus. by, 115

Van Gogh, Vincent, illus. by, 97

Varnish, copal, 19; damar, 19; mastic, 19

Vibration, 41-42; by combining methods, 61-62; *see also* Impressionist Technique; Juxtaposition; Plastic quality; Pointillist technique

Watercolor, 17

Weight, 84

Wet-on-wet, 17; illus., 120; *see also* Painting techniques

White, titanium and zinc compared, 33

Edited by Susan E. Meyer
Designed by James Craig
Composed in twelve point Baskerville